Experimental Formats
—Books
—Brochures
—Catalogues

Experimental Formats
—Books
—Brochures
—Catalogues

Compiled and edited by
Roger Fawcett-Tang

Introduction by
Chris Foges

Section introductions by
John O'Reilly

A RotoVision Book
Published and Distributed
by RotoVision SA
Rue du Bugnon 7
1299 Crans-Près-Céligny
Switzerland

RotoVision SA
Sales and Production Office
Sheridan House
112–116a Western Road
Hove, East Sussex, BN3 1DD, UK
Telephone: +44 (0) 1273 72 72 68
Facsimile: +44 (0) 1273 72 72 69
E-mail: sales@rotovision.com
Website: www.rotovision.com

Distributed to the trade
in the United States by
F&W Publications, Inc.
1507 Dana Avenue
Cincinnati, Ohio 45207

10 9 8 7 6 5 4 3

ISBN 2-88046-508-7

Book designed by Struktur Design
Photography by Xavier Young

Production and separations by
ProVision Pte. Ltd. in Singapore
Telephone: +65 334 7720
Facsimile: +65 334 7721

Printed in China

A

B

In around 1455, Johann Gutenberg watched as pages of the Bible rolled off the first Western press using movable metal type. He may have realised something of the significance of the event, but he could hardly have anticipated the situation we would find ourselves in slightly more than 500 years later. More new books are published every day than Gutenberg saw in a lifetime; magazines on every subject under the sun and brochures promoting every conceivable product are churned out daily in their millions. Standardised production of printed materials – books, magazines, pamphlets, brochures – has allowed the spread of ideas, defined cultures and economies, catalysed conflict and propagated belief systems: in short, shaped our world. Improvements in printing technology have kept pace with demand for print. But while, for largely practical reasons, there has been a general trend towards uniformity and slick consistency in the physical production of published materials, alongside has run a healthy tradition for experiment with the printed form – experiment with structure, shape, materials, function – creating pieces of print which stand out on their physical merits alone.

00_Introduction

"With the possible exception of books... everything you design is destined to be thrown away. And pretty quickly too."
Karrie Jacobs

A006|007

Because the printed word is so central to our culture, books – and to a lesser extent magazines and brochures – are among the few exceptions to a general rule applied to graphic design: that it is essentially ephemeral. Printed literature holds its value longer than the bus ticket or food wrapper. The lucky ones not only escape the landfill but are used, and even cherished. "No furniture so charming as books," averred the essayist Sydney Smith. And among so much paper furniture, it is often the unusual or unique which become the classic pieces. When the Dutch multinational SHV wanted to commemorate its centenary, it could have commissioned a piece of sculpture or a painting for the chairman's office. Instead, it asked designer Irma Boom to create a verbal and pictorial expression of the company's character and history in the form of a book. And it was not just any book: at over 2,000 pages, and weighing in at eight pounds, the 'Thinkbook' was a significant technical, as well as creative achievement, and took Boom five years to complete. A limited edition of just 4,000 copies was produced.

Most books, magazines or brochures with experimental formats do appear in comparatively small editions, often because the need to hand-finish each copy makes them expensive, precluding large runs. The care that goes into creating each copy, as well as the sense of rarity, is central to their appeal; is it far-fetched to suggest that some of the pleasure we get from handmade objects is the sense of connection with the person that made it?

A006:01 | A007:01
See page
B020:01|02 →
B021:01|02|03 →

There was a time, not so long ago, when every printed sheet was unique. Letterpress type, with its microscopic variations from impression to impression, and hand-operated cutting and binding machines gave each page its own character. Today, when most design is done at a computer, and printing presses throughput paper faster than the eye can follow, there is a sense of remove between the designer and the physical creation of an object. Books, magazines and brochures with unique or experimental formats do not necessarily utilise any more craft skills than their more conventional cousins, but the input of the designer or craftsman is more obvious, and accounts for a large part of their appeal.

"Another damned, thick, square book. Always scribble, scribble, scribble! Eh! Mr. Gibbon?"
William, Duke of Gloucester

Print is commonly assumed to appeal to one sense alone – sight. But inks and glue smell, and paper rustles. The most obvious physical property of printed literature, though, is its weight, its heft, its tactility: books, magazines and brochures are objects designed to be held in the hands. Our sense that books are 'objects', as well as collections of words and pictures, is part of the reason we cherish them as possessions – all the more so if they are unusual. 'One Woman's Wardrobe', featured in this book, is a catalogue for clothes collector Jill Ritblatt's Victoria & Albert Museum exhibition. But it is more than that. By incorporating fastenings and handles into the plastic cover, in the style of a handbag, designers Area created a catalogue whose very shape demands that it should be picked up and carried away. It is a catalogue which reflects Ritblatt's interests through its form as well as its contents, but one which is also a thing in its own right, a thing with presence and purpose. Like the clothes, it has become a collector's item.

ECHOES
OF
SWEET
NESS

"A good solution, in addition to being right, should have the potential for longevity. Yet I don't think one can design for permanence. One designs for function, for usefulness, rightness, beauty. Permanence is up to God."

Paul Rand

A008|009

Among the examples contained within this book, few, if any have been designed solely as ornaments. Instead, experimental forms are prescribed by function. When a book, magazine or brochure is not in use, it is stored – usually on a shelf. No law governs this, however, and this collection contains literature designed to hang from its spine, stack, roll, fold.

When the book is in use, its primary purpose is to convey information. The way in which information is presented affects its meaning, and fundamentally, the designer's job is to interpret, on behalf of the writer, what information they wish to convey, and on behalf of the reader, how they want to receive it. This process is by no means fixed. Much is made today of the extra dimension hypertext links bring to web sites. As readers become more used to this way of consuming written material, it may be that designers for print will have to address some of our fundamental assumptions about how people want to navigate printed literature. The design of this book recognises that the ability to instantly cross-reference between examples, or to view two simultaneously, may add depth to the reading experience.

A008:01|02
See page
A062:01|02 →

Admittedly, at first glance this book may appear complex, difficult even. But deriving benefit from it is just a matter of becoming attuned to a new way of reading, something we do constantly and almost without realising it. Just as we might find the text-heavy magazines of the last century taxing today, Emigre magazine editor Rudy VanderLans once observed that those who grew up as part of the MTV generation read differently to those who grew up before it: "They are attracted and enticed to read something because of the visual richness." The experience of watching MTV is as much to do with visual sensation as sound. Although most print work is not wired for sound, it does have an advantage over television when it comes to creating 'visual richness': graphic design, as is often forgotten, works in three dimensions – structure, form and physical interaction all play their part. This is especially true in the case of books, magazines and brochures, which must be handled to be used.

There are other, practical benefits to using an unusual format: it stands out, and shelf shout is good for business. Famously experimental firms such as <u>The Attik</u>, whose work appears in this book, are in constant demand from 'straight' corporate clients as well as those in the arts. In those circumstances the main objective is often to be seen and remembered – even before the fringe benefits of being associated with originality, fun or inventiveness are enjoyed.

"The prerequisite of originality is the art of forgetting, at the proper moment, what we know."
Arthur Koestler

'Breaking the rules' does not just happen when the designer is in pursuit of a particular 'benefit', however. The fact that designers continue to search for new ways to present printed material after 600 years is, as much as anything, evidence of a deep-rooted human desire to try alternatives.

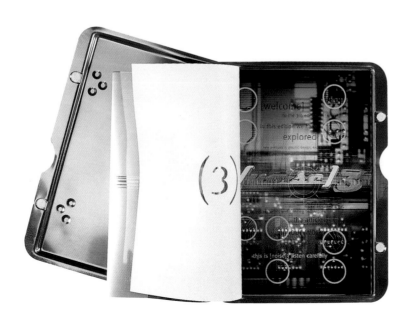

And yet, however deep-rooted the desire may be, the decision to experiment is almost always conscious, and often involves deliberately trying to do something which seems absurd or 'wrong'. Often, it is only by trying something new for the sake of it that a potential benefit is discovered; exploration and experiment open up new ways of thinking and working from conceptual and technical standpoints. Edward de Bono, the inventor of the term 'lateral thinking', suggests that one of the best ways to arrive at a new idea is by deliberately tripping oneself out of familiar thought processes with a 'provocation' – a suggestion that seems, on the surface, irrelevant to the problem in hand. This book contains, among other things, a jewellery catalogue that contains neither words nor images, and a catalogue bound with a wire coat hanger, designed to be stored in suspension. In each case the potential benefits could only have become apparent once the designer had consciously decided to become open to new ideas.

"Sometimes there is simply no need to be either clever or original."
Ivan Chermayeff.

The argument is sometimes made today that the only future for print is as ornament or luxury, and that digital media will do for the rest. Boom-time, it might appear, for those whose interest is confined to unusual materials or experimental formats in print. But it seems likely that even the most conventional books, magazines and brochures will be with us, probably in even greater numbers, for some time yet. Print does have certain advantages over fragile matrices of 1s and 0s, not least of which is longevity. So, a thousand years after the Chinese first pressed wooden blocks into paper, we find ourselves at a time when print is ubiquitous, but perhaps at the cost of uniformity. This is a necessary trade-off, and this book does not intend to suggest that experimental formats are 'the future of print', or even 'the best of print'. Rather, it shows what can be achieved when designers are willing to entertain new ideas in search of the exceptions, and not the rule.

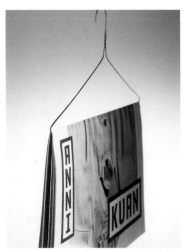

A010:01
See page
A051:02 →

A011:01
See page
B011:01|02|03 →

A011:02
See page
B044:01 →
B045:01|02 →

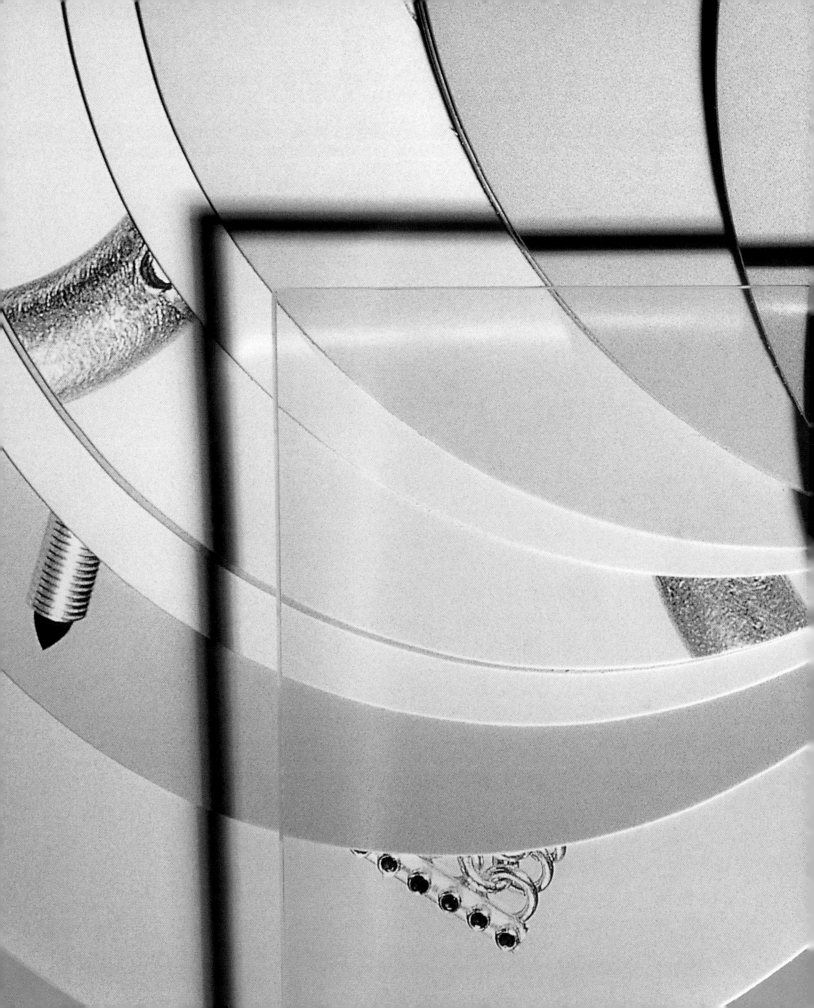

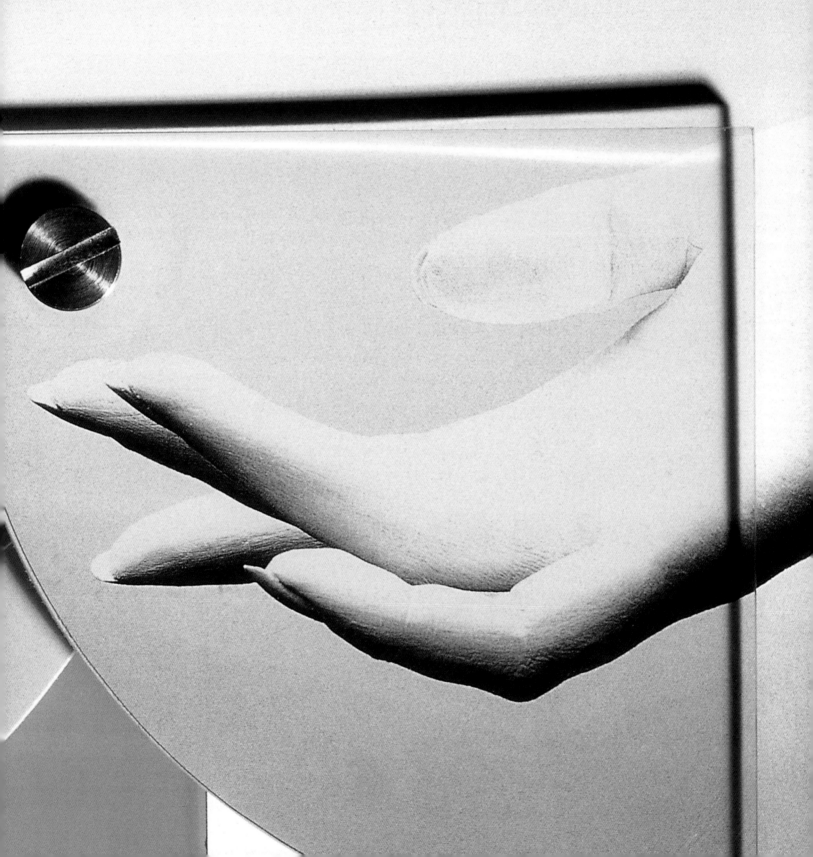

01_Proportions

In this first section all the books featured are reproduced at 25 per cent of their original size. At the foot of each caption is a page reference, which denotes where that particular work is shown in more detail.

Within the main body of the book, page reference numbers are used on the left or right edge of the page, indicating where further examples by the same designer can be found in other sections.

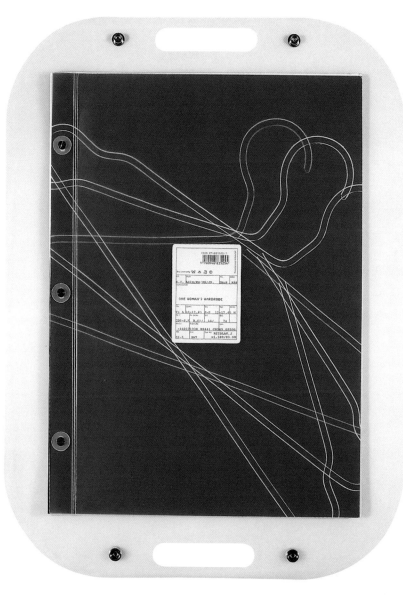

Design: Area
Title: Koji Tatsuno
306 x 218 x 22mm
32 pages
1990
United Kingdom

See page: A063:02

Design: Area
Photography: Toby McFarlan Pond
Title: Tina Engell Jewellery
132 x 132 x 20mm
40 pages
1996
United Kingdom

See page: B057:01

Design: Area
Photography: Toby McFarlan Pond
Title: One Women's Wardrobe
594 x 440 x 6mm
50 pages
ISBN: 094883525-7
1998
United Kingdom

See page: A062:01|02

RADIOACTIVITY WARNING

A FUTURESCAPE

← 01

Published in a limited edition /800

Design: Area
Title: Paul & Joe Spring/Summer 1998
172 x 140 x 8mm
54 pages
1998
United Kingdom

See page: A074:01

Design: The Attik
Title: Radioactivity Warning
385 x 250 x 17mm
74 pages
ISBN: 0-9534606-0-6
1998
United Kingdom

See page: A51:01

Design: The Attik
Title: (Noise) 3
360 x 275 x 17mm
124 pages
1998
United Kingdom

See page: A051:02

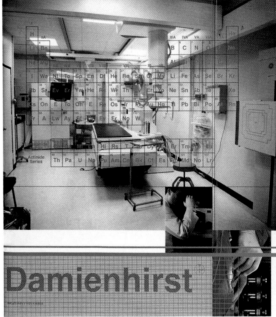

Design: Phil Baines
Artist: Melanie Counsell
Title: Catalogue/Annette
267 x 355 x 70mm
Catalogue: 72 pages
Annette: 264 pages
ISBN: 1 902201 00 0
ISBN: 1 902201 00 9
1998
United Kingdom

See page: A045:01
See page: A078:01

Design: Jonathan Barnbrook
Artist: Damien Hurst
Title: I Want to Spend the Rest of
My Life Everywhere, with Everyone,
One to One, Always, Forever, Now
338 x 300 x 38mm
366 pages
ISBN: 1-873968-44-2
1997
United Kingdom

See page: B076:01|02
See page: B077:01|02|03

Design: Blast
Title: One Family
155 x 113 x 30mm
68 pages
1999
United Kingdom

See page: A046:01

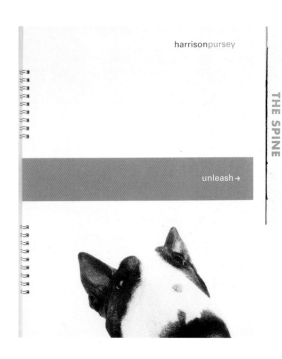

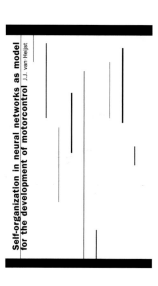

Design: Blast
Title: HarrisonPursey – Unleash
330 x 250 x 4mm
20 pages
1999
United Kingdom

See page: B055:01

Design: Irma Boom
Title: The Spine | Da Appel
210 x 148 x 8mm
56 pages
1994
Holland

See page: B052:01

Design: Irma Boom
Title: SHV ThinkBook
226 x 170 x 114mm
2136 pages
1996
Holland

See page: B020:01|02
See page: B021:01|02|03

Design: Kristel Braunius
Title: Self-organization in neural networks as model for the development of motorcontrol
260 x 170 x 11mm
140 pages
ISBN: 90-367-1001-4
1998
Holland

See page: B053:01

Designer/Artist: Paolo Carraro
Title: The Impermanent
in the Permanent
200 x 215 x 8mm
40 pages
1996
United Kingdom

See page: B068:01|02
See page: B069:02

Designer/Artist: Paolo Carraro
Title: The Impermanent
in the Permanent (mono version)
216 x 216 x 23mm
40 pages
1996
United Kingdom

See page: B069:01

Design: Cartlidge Levene
Title: Canal Building
210 x 168 x 7mm
104 pages
1999
United Kingdom

See page: B039:01|02

Design: Cartlidge Levene
Title: Designing Effective
Annual Reports
258 x 179 x 6mm
44 pages
1994
United Kingdom

See page: B030:01|02

Design: Cartlidge Levene
Title: NatWest Media Centre
Lord's Cricket Ground
260 x 215 x 7mm
32 pages
2000
United Kingdom

See page: A059:01|02

Design: Cartlidge Levene
Title: TypoGraphic 51
295 x 212 x 2mm
32 pages
ISBN: 0143 7623
1998
United Kingdom

See page: B034:01-05
See page: B035:01|02|03

Art director: Gary Cochran
Packaging: Artomatic
Title: It – Experiment
188 x 188 x 40mm
32 pages
2000
United Kingdom

See page: A079:01

Design: John Cole
Artist: Verdi Yahooda
Guidelines to the System
234 x 180 x 11mm
48 pages
ISBN: 1 870699 04 1
1990
United Kingdom

See page: B058:01|02

Design: cyan
Title: Tod Versuche Mich
Scardanelli Poesien
150 x 115 x 11mm
192 pages
ISBN: 3-932193-01-6
1999
Germany

See page: B006:01|02

Design: cyan
Title: Form+Zweck 11/12
324 x 211 x 13mm
152 pages
1994
Germany

See page: B060:01|02|03|04

Design: John Crawford +
Nick Thornton-Jones
Title: Ghost Menswear
206 x 297 x 46mm
28 pages
2000
United Kingdom

See page: A055:01|02

Design: Warren Denyer Design
Title: Exposé
160 x 160 x 2mm
24 pages
1996
United Kingdom

See page: B010:01|02

Design: Designframe
Photography: François Robert
Title: Seeing: Doubletakes
210 x 210 x 12mm
78 pages
1998
United States of America

See page: B015:01|02

Design: Mark Diaper
Artist: Janet Cardiff
Title: The Missing Voice (Case Study B)
240 x 170 x 12mm
72 pages
ISBN: 1-902201-07-8
1999
United Kingdom/Holland

See page: A070:01|02|03

Design: Mark Diaper
Artist: Rachel Lichtenstein
Title: Rodinsky's Whitechapel
165 x 110 x 10mm
88 pages
ISBN: 1-902201-06-X
1999
United Kingdom/Holland

See page: B054:01|02

Design: Birgit Eggers
Title: Central St. Martins
Fashion Degree Catalogue
310 x 220 x 20mm
76 pages
1995
United Kingdom

See page: B050:01

Design: Birgit Eggers
Title: Radar Glass
38 x 54 x 2mm
38 pages
1998
United Kingdom

See page: B074:03|04|05

Design: Paul Farrington
Artist: Jorn Ebner
Title: Handbook for
a Mobile Settlement
148 x 105 x 5mm
40 pages
1999
United Kingdom

See page: B028:01|02

Design: Jaq La Fontaine
Title: G-Star Raw Denim s/s 2000/01
250 x 415 x 40mm
60 pages
1999
Holland

See page: A068:01|02

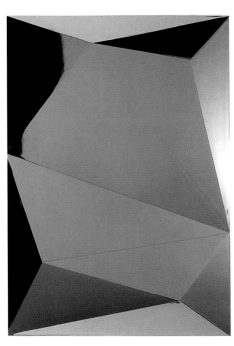

Creative director: Stephen Gan
Photography: Karl Lagerfeld
Title: Visionaire 23
The Emperor's New Clothes
390 x 320 x 43mm
90 pages
1997
United States of America

See page: A044:01

Creative director: Stephen Gan
Design: Design/Writing/Research
Title: Visionaire 27 Movement
316 x 247 x 23mm
144 pages
1999
United States of America

See page: A074:01
See page: A075:01

Creative director: Stephen Gan
Art director: Greg Foley
Design: Judith Schuster
Title: Visionaire 29 Woman
340 x 240 x 25mm
124 pages
1999
United States of America

See page: A048:01
See page: A049:01

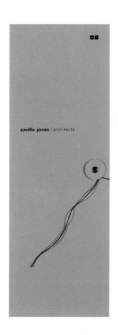

Design: Graphic Thought Facility
Title: Stealing Beauty –
British Design Now
252 x 150 x 9mm
106 pages
1999
United Kingdom

See page: B055:02

Design: Melle Hammer
Title: AAA OOO EEE – Confetti 25
200 x 160 x 5mm
54 pages
1991
Holland

See page: B059:01|02|03

Design: hdr design
Title: Saville Jones Architects
310 x 110 x 2mm
14 pages
1999
United Kingdom

See page: B029:01

Design: hdr design
Title: Michael Bischoff Schmuck
100 x 100 x 3mm
16 pages
1998
United Kingdom

See page: B026:01

MICH
BETRIFFT
ES NICHT

Design: hdr design	Design: HGV	Design: HGV	Design: Harco van den Hurk
Title: Baseline Invite	Title: Size Doesn't Matter	Title: See	Title: Engagement
150 x 150 x 1mm	40 x 140 x 6mm	148 x 105 x 9mm	510 x 700 x 20mm
6 pages	24 pages	78 pages	92 pages
1995	1999	1998	1992
United Kingdom	United Kingdom	United Kingdom	Holland
See page: B038:01\|02	See page: A061:01	See page: B031:01	See page: A060:01

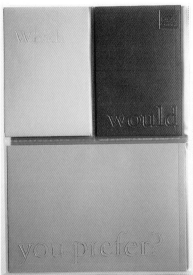

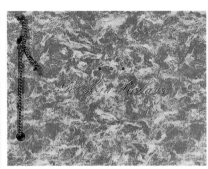

Design: Anke Jaaks	Design: Johnson Banks	Design: Johnson Banks	Design: KesselsKrammer
Title: Wolfgang Schmidt –	**Title: Tom Dixon – Rethink**	**Title: Which Would You Prefer?**	**Title: Geloof in Reclame**
Worte und Bilder	**280 x 216 x 15mm**	**297 x 210 x 10mm**	**163 x 216 x 11mm**
241 x 151 x 28mm	**128 pages**	**132 pages**	**42 pages**
2 x 128 pages	**1998**	**1999**	**1998**
1992	**United Kingdom**	**United Kingdom**	**Holland**
Germany			

See page: B062:01
See page: B063:01|02|03

See page: A079:02

See page: A043:01|02

See page: B049:02

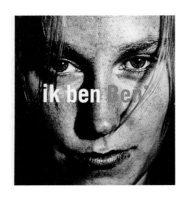

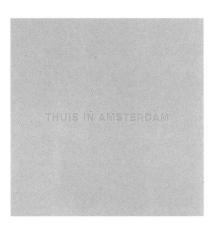

Design: KesselsKrammer
Title: Nike Autograph Book
125 x 125 x 8mm
14 pages
1997
Holland

See page: A071:01|02

Design: KesselsKrammer
Title: ik ben Ben
197 x 179 x 31mm
32 pages
1998
Holland

See page: B048:01

Design: KesselsKrammer
Title: Thuis in Amsterdam
210 x 210 x 8mm
40 pages
1999
Holland

See page: B057:01

Design: KesselsKrammer
Title: do Future
180 x 105 x 8mm
144 pages
1999
Holland

See page: A050:02|03

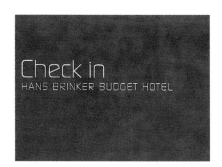

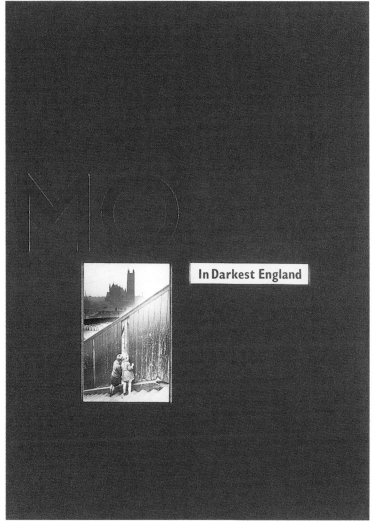

Design: KesselsKrammer

Title: Check In –

Hans Brinker Budget Hotel

155 x 215 x 5mm

48 pages cut in half

1999

Holland

See page: B075:01|02

Design/Editor: David Jury

Title: In Darkest England

550 x 400 x 27mm

46 pages

1997

United Kingdom

See page: B050:02
See page: B051:01|02

Artist: Hans Peter Kuhn

Title: Künstlerhus Bethanien Berlin

240 x 165 x 7mm

16 pages

ISBN: 3-923479-70-0

1992

Germany

See page: B019:01

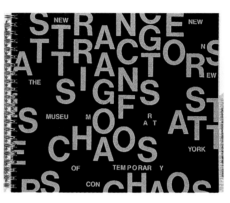

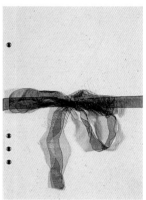

Design: Lab
Title: 04/97/inIVA Review/
297 x 210 x 12mm
12 x A2 posters
1997
United Kingdom

See page: A058:01|02|03

Design: Herman Lelie
Artist: Christopher Wool
Title: Ophiuchus Collection
224 x 163 x 10mm
28 pages
1998
United Kingdom

See page: B036:01|02

Design: M&Co.
Title: Strange Attractors: Signs of Chaos
190 x 228 x 8mm
72 pages
1989
United States of America

See page: B049:01

Design: Takaaki Matsumoto
Title: Material Dreams
205 x 145 x 6mm
72 pages
1995
United States of America

See page: B047:01

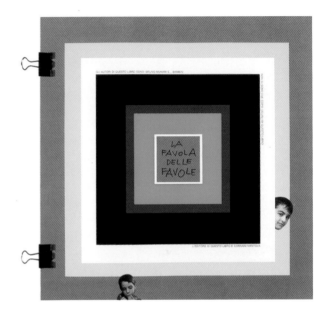

Design: MetaDesign London
Title: Transig
297 x 210 x 3mm
24 pages
1998
United Kingdom

See page: A076:01

Design: Britta Möller
Title: Kijken & Denken
120 x 100 x 40mm
152 pages
60 x 50 x 10mm
18 pages
60 x 50 x 10mm
18 pages
1998
Holland

See page: B061:01|02

Design: Bruno Munari
Title: La Favola delle Favole
300 x 300 x 9mm
126 pages
ISBN: 88-86250-60-6
1994
Italy

See page: B070:01|02|03

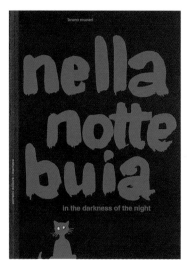

Design: Bruno Munari
Title: Nella Notte Buia –
In the Darkness of the Night
235 x 165 x 10mm
60 pages
ISBN: 88-86250-38-X
1996
Italy

See page: B074:01|02

Design: North
Title: Dome
185 x 185 x 5mm
84 pages
ISBN: 1-86154-148-1
2000
United Kingdom

See page: A042:01

Design: North
Title: The Citibank Private Bank
Photography Prize 1999
304 x 213 x 10mm
68 pages
ISBN: 0907879551
1999
United Kingdom

See page: A077:01

Design: North
Title: The Citibank Private Bank
Photography Prize 2000
297 x 210 x 4mm
40 pages
ISBN: 0907879578
2000
United Kingdom

See page: B007:01

Design: North
Title: Panache
175 x 130 x 20mm
256 pages
1998
United Kingdom

See page: B016:01|02
See page: B017:01

Design: North
Title: Jacqueline Rabun
303 x 215 x 7mm
28 pages
ISBN: 0-9531463-0-8
1999
United Kingdom

See page: B011:01|02|03

Design: Ontwerpbureau 3005 /
Marc Vleugels
Artist: William Engelen
Title: Intermission no. 3
160 x 227 x 9mm
92 pages
1999
Holland

See page: A071:03

Design: olly.uk.com
Photographer: Kent Baker
Title: Levi's Vintage Clothing
Spring 2000
245 x 190 x 10mm
90 pages
1999
United Kingdom

See page: A069:01|02

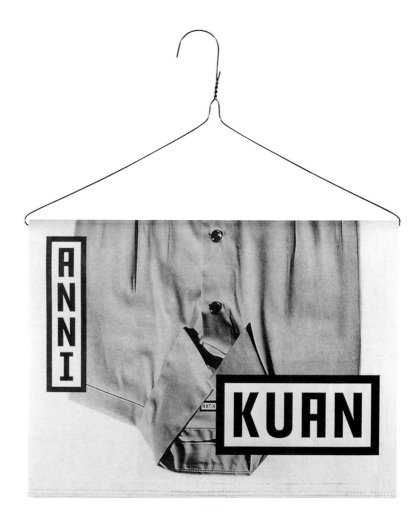

Design: The Partners	Design: Roundel	Design: Sagmeister Inc.		
Title: Silk from France	Title: Pure	Title: Anni Kuan Design		
210 x 148 x 3mm	210 x 148 x 2mm	290 x 395 x 1mm		
16 pages	16 pages	28 pages		
1997	1997	1999		
United Kingdom	United Kingdom	United States of America		
See page: A063:01	See page: B036:03	See page: B044:01		
	See page: B037:01	02	See page: B045:01	02

Design: Sagmeister Inc.

Title: American Photography 15

322 x 245 x 35mm

340 pages

ISBN: 1-886212-11-2

1999

United States of America

See page: B008:01|02

Design: Zoe Scutts

Title: Untitled

74 x 50 x 7mm

34 pages

2000

United Kingdom

See page: B046:01

Design: SEA

Title: Substance Invite

218 x 141 x 12mm

62 pages

1999

United Kingdom

See page: A047:01

Design: SEA

Title: London: Cloudy –

Graphic Textures

200 x 155 x 15mm

52 pages

1998

United Kingdom

See page: A046:02

Design: SAS | Marek Gwiazda
Title: Maria Harrison Synthesis
320 x 317 x 5mm
40 pages
1998
United Kingdom

See page: A072:01|02

Design: SAS
Title: BT – Charting the Virtual World
237 x 207 x 20mm
84 pages
1999
United Kingdom

See page: B018:01|02

Design: The Thompson Design Office
Title: Missing Pages
200 x 163 x 6mm
16 pages
1999
United Kingdom

See page: B027:01|02|03

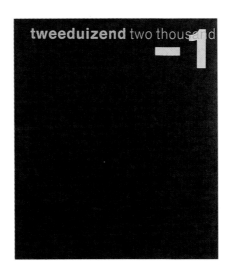

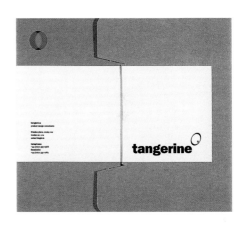

Design: UNA (Amsterdam)
Title: Voices
320 x 245 x 27mm
168 pages
1998
Holland

See page: B014:01|02

Design: UNA (Amsterdam)
UNA (London)
Title: Tweeduizend –1
255 x 224 x 30mm
350 pages
1998
United Kingdom/Holland

See page: B032:01
See page: B033:01|02

Design: Union Design
Title: The Tangerine Book
205 x 235 x 17mm
64 pages
1995
United Kingdom

See page: B072:01|02
See page: B073:01

Design: Ulysses Voelker
Title: Zimmermann
Meets Spiekermann
280 x 214 x 8mm
42 pages
ISBN: 3-929200-01-5
1992
Germany

See page: A076:02

Design: Wolff Olins
Title: Yacht – to the next curve
150 x 150 x 20mm
58 pages
1999
United Kingdom

See page: B056:01|02

Design: Wolff Olins
Title: Made in Italy
280 x 228 x 4mm
24 pages
1996
United Kingdom

See page: B071:01|02

Design: xheight
Title: Trans >6
254 x 203 x 15mm
220 pages
1999
United States of America

See page: B012:01
See page: B013:01

02_Packaging

"A word from our sponsors: I am 32 years old and my face looked like that of a 15 year old who eats chips and french-fries too often. The first night, as I was applying Forever Young cleansers, I thought to myself, 'I should have taken some before pictures'. I cleansed, perfected and renewed, and as I got into bed, I told my husband, 'You know my face feels like fresh flower petals from the inside and to the touch.'" From 'do Future' by KesselsKramer.

The excerpt from a book by Dutch advertising agency KesselsKramer is a parody of the packaging we indulge in everyday on make-up, shaving, dressing-up, combing our hair.

Despite the fact that packaging is something we all do, it's strange that packaging in our culture is regarded with suspicion. At best it's seen as something extra to the packaged object contained. Packaging is a kind of necessary evil, but we know it's not to be confused with the real thing contained inside. This suspicion of packaging runs deep. It's reflected in the religious belief that the human body is merely packaging around our true selves, our soul.

At worst 'packaging' is a kind of disguise. It's a kind of interference. It muddies our unmediated experience of what's inside. Our anxiety about packaging is a symptom of a wider phenomenon. Within Western culture there is a residue of iconoclasm, the medieval heresy that believed that any representations of God were idolatrous. The truth can only be experienced directly without the packaging of statues, paintings and murals. It's no accident that when this cultural prejudice is applied to books you end up with a whole moral code. How often are we reminded as children that we should "Never judge a book by its cover".

And yet the Judeo-Christian belief system which has outlasted its competitors was built on as fine an example of packaging that a modern designer could wish for. How did God package the unbreakable laws that humanity was obliged to live by? Did God create papyrus so Moses could carry his Law down the mount? No sir. The Judeo-Christian God may have been all-powerful but he was also a semiotician. He knew how to communicate messages.

The Ten Commandments were chunky, monumental bits of stone. Suppose the Laws Of God had been written on paper. Would Moses tearing them up in anger have really left his audience trembling in fear? It would have seemed like the act of a petulant drama queen. Moses had to hurl in anger the tablets of stone, and the crack as they broke echoed down the centuries as a symbol of divine anger. Even now, during morning prayers, the reverence in which Orthodox Jews hold the Torah is reflected in the act of tying *tefillin*, boxes containing parchment, onto their forehead and arms. By regarding the packaging of books as something unnecessary we miss the impact of the message they carry.

Roland Barthes in 'The Empire Of Signs' illustrates how eccentric and particular the view Western culture has towards packaging when contrasted with the more subtle and inventive Japanese philosophy of packaging: "Geometric, rigorously drawn, and yet always signed somewhere with an asymmetrical fold or knot, by the care, the very technique of its making, the interplay of cardboard, wood, paper, ribbon, it is no longer the temporary accessory of the object to be transported, but becomes itself an object… the package is a thought."

So the thought communicated in the packaging of 'do Future' by KesselsKramer is so fascinating. Unusually for an ad agency they spend a lot of time producing and publishing books. Erik Kramer, one of the co-founders of KesselsKramer, explains: "We don't see ourselves as an advertising agency but more like a communications agency. We try to work in fields outside of advertising. A few months ago we did a video for Tom Waits for example. We made stamps for the Post Office, which is not a typical job for an ad agency. With books we started our own publishing company. We didn't want to act like a serious publishing company but wanted to give creative people in the agency a chance to generate some ideas about books."

What KesselsKramer have recognised and have fed off as an agency is the fetishistic power of certain kinds of books. Their fabulous, if eccentric, books have been deployed not simply as a generalised marketing tool – though it's true that their books have generated attention for the agency. Books such as 'do Future' are not vanity publishing or an indulgent decoration. The books aren't simply a sign of 'creativity' that allows clients to believe they're not just buying commercial skills but are purchasing cultural kudos by employing a maverick company. KesselsKramer books are idea-machines in themselves.

Take, for example, the packaging of this 'do Future' book. The book is covered in transparent polythene. According to Erik Kramer, the transparency of the cover reflects the idea that if the future is open, then its packaging also should be open in the same way.

The packaging is more than just the cover for this particular book. The transparent cover communicates and telescopes the whole idea of 'do Future' and KesselsKramer. The 'do Future' concept was conceived by KesselsKramer as a brand without a product. So in a sense, the cover of 'do Future' is the packaging of packaging. It's the wrapping of something that's already wrapping. There is, it seems at first glance, no content.

Of course there is. The 'do Future' brand has content. But paradoxically, the packaging is so transparent, too clear, that you can't see the content, because the content itself is the idea of 'the open'. The concept of the transparent and the

open was popularised in the late '90s with the iMac. The popularity of iMac's design wasn't simply a reflection of a sudden taste for dinky, candy-coloured computers. The transparency of the machine was at one with the transparency of communication which internet technology was now bringing. And by allowing the proud owner to see the hardware inside the machine, the anonymous box of technology was thus demystified.

The transparency of the 'do Future' packaging was reflected in various ad campaigns like the one for the Hans Brinker Hotel. For this budget hotel aimed at the youth market, KesselsKramer generated an anti-campaign based on 'honesty'. Posters for the hotel declared: "Now even more noise"; "Now even less service"; "Now a door in every room"; "Even more dogshit in the main entrance". The hotel's turnover increased by 40 per cent.

KesselsKramer are marketing the 'do' brand as a kind of demystification. Erik Kramer sees 'do' as an interactive interface between the consumer, and "With 'do' we wanted to build a brand mentality with something ever-changing that depends on you. That means that the consumer in contact with the brand has to interact. A lot of products are passive. We now have started to connect products to it. We did a project called 'do Create'. We also made a catalogue for it. It's a project we do with 15 product designers. We briefed them on the idea of 'do'. Normally when you buy a chair it can only depreciate over time. In ten years' time you throw it out on the street and it's gone. In the 'do' collection there is one chair with one shorter leg. It doesn't function properly as a chair, it leans over. But you have to be creative to use it, like putting your favourite books under the shorter leg and balancing it."

In a world of alien brands and products which promise the consumer a more beautiful life, KesselsKramer are banking on the appeal of the idea that the 'Truth Is Out'. But there is a problem that's also disclosed by the cover. The charm of what they do, the humour of turning convention upside down depends on maintaining a kind of mystique, an uncertainty of tone, a perception on the part of the audience as to whether the ads are for real. If demystifying the channels of communication is your only card, you can end up looking as if you are trying too hard. Like their own ad for the video of KesselsKramer TV ads, which declares "Go to www.kesselskramerforsale.com and soon you can watch the commercials over and over again. Includes films with naked people, dogs, men behaving like dogs, cows, kangaroos and old grannies." A taxonomy of 'the wacky'. But this is what's left when transparency rules.

If the transparent cover of 'do Future' is the perfect cover for the open brand, the Dome book produced by designers North is also about the packaging of packaging. It's no surprise that the Japanese considered buying the Dome, because as Barthes argued, the Japanese would be sensitive to the wrapping on wrapping that was the Dome.

The Dome became the architectural signifier of 'Millennium'. If the concept of the Millennium was a trifle vague, the Dome itself is a mythic monument to the architecture of absence. It is the monolith of 2001 transplanted to the Isle of Dogs. The more desperately politicians attempted to fill the 'Millennium' and its most manifest symbol, the Dome project, with meaning, the more resolutely did the massive edifice resonate with the silence. The Dome was a piece of pure packaging. The content would always be exceeded by the frame. In effect the Dome was an example of 'do' architecture, a monument whose size was a testament to openness and could only be undone by filling its space.

The Dome book itself is a piece of architecture. Mason Wells, designer at North, explains the book's design: "We try and take formats and materials as far as we can. We try print as an object as much as a flat piece of paper. The physicality of it is what produces the idea. For something like the Dome it was really about trying to produce a piece of micro-architecture. If you look at the dot-matrix typography, everything is circular except for the 90-degree corner which allows you to stack it on a shelf."

And in order to capture what the Dome means there is nothing that could have been put in this shell other than what it eventually contained – photographs of the Dome itself under construction. The dot-matrix font pulls the reader into digital pre-history, the 1980s. When laser and inkjet printers were the spoils of multinational corporations, the dot-matrix font echoed the golf-ball print technology of the electronic typewriter. The packaging of the Dome book is an elegant solution to the problem of representing the perfect shell.

If the Dome book is the Y2K meta-package, it is Visionaire magazine which saw what was truly at stake in the concept of packaging. Visionaire is not simply a high-end fashion magazine. It is fashion conceived as pure packaging. It is not the triumph of style over content, because Visionaire's packaging takes the logic of fashion at its word and erases the distinction between them. Fashion is the PR of the body, the spin of the flesh. Visionaire is the magazine of the information age where we have user-names and virtual bodies.

In a non-pejorative sense Visionaire's appeal is the beauty of pure hype. And in the absence of any content that is not self-referring, it is hype itself. For example, Visionaire 23, 'The Emperor's New Clothes', doesn't include fashion by designer Karl Lagerfeld. It is, itself, created by Karl Lagerfeld. It is fashion. And if Visionaire 29, 'Woman' looks like a stealth bomber it is because, like KesselsKramer's 'do' concept, 21st-century packaging will be invisible. Because what's being sold is the package itself.

A040:01
Also see
A050:02|03 →

A041:01
Also see
B075:01|02 →

A041:02
Also see
A042:01 →

A041:03
Also see
A044:01 →

A041:04
Also see
A048:01 →
A049:01 →

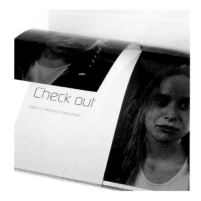

A042:01
Design: North
Title: Dome
185 x 185 x 5mm
84 pages
ISBN: 1-86154-148-1
2000
United Kingdom

Produced as a photographic record of the construction of the Millennium Dome in London, this book is housed in a custom-made circular plastic container. With reference to the Dome, the book has been produced in a circular format, with an angled corner in the bottom left to increase the stability of the binding.

The plastic case has a milky, matt finish with the title in a dot-matrix font embossed into the surface. An L-shaped label containing imprint details is carefully positioned into a recessed area on the front; this information is repeated on the front cover of the book.

The book itself is predominantly photo-led, with captions and soundbites of information printed in white-out curved panels. Halfway through the book is a 16-page section printed on white simulator paper showing CAD drawings of the various levels of the infrastructure of the Dome.

A043:01|02
Design: Johnson Banks
Title: Which Would You Prefer?
297 x 210 x 10mm
132 pages
1999
United Kingdom

The 1999 annual review for the Design Council of Great Britain comes as a kit of parts, comprising an A6 36-page book , 'An overview', outlining who the Design Council are; a set of three A6 reply postcards, 'An opportunity to feedback'; an A5 landscape 48-page book, 'Facts, figures and quotable quotes', and the A4 48-page annual review itself. All these disparate parts are carefully contained within the various welded wallets of the PVC gatefold cover.

From the front the only text visible is the title and the Design Council logo, which are all embossed into the surface of the plastic.

A044:01
Creative director: Stephen Gan
Photography: Karl Lagerfeld
Title: Visionaire 23
The Emperor's New Clothes
390 x 320 x 43mm
90 pages
1997
United States of America

Visionaire is a quarterly publication aimed at the fashion industry, with a different guest art director on each issue. Issue 23 was created by the renowned fashion designer Karl Lagerfeld, who shot every image for this issue. The sub-title of this issue is 'The Emperor's New Clothes': Lagerfeld photographed various male and female nude studies of celebrities and models.

The issue is a collection of 45 loose-leaf sheets, with one portrait on each. The reverse side just has the model's name written discreetly at the base. These sheets are sandwiched between two sheets of dark brown flocked card front and back, bound by a large ribbon with the title and issue details printed in gold. The whole issue is contained within a custom-built hinged wooden box with a leather carrying handle.

A045:01
Design: Phil Baines
Artist: Melanie Counsell
Title: Catalogue/Annette
267 x 355 x 70mm
Catalogue: 72 pages
Annette: 264 pages
ISBN: 1 902201 00 0
ISBN: 1 902201 00 9
1998
United Kingdom

This artists' book comprises two separate
publications, 'Catalogue' and 'Annette', which
are encased in a custom-made polystyrene
box. The outer box is adorned with a simple
white label which explains the contents.
The whole package is rather austere, and
is somewhat reminiscent of a piece of
medical equipment.

Once the cover is lifted off, the top book,
'Annette' is revealed, a solid black cover with
the title white-out. Both books sit within
a recess made in the polystyrene and are
wrapped with a plain black ribbon to
enable the books to be lifted and
removed from the container.

A044:01
Also see
A048:01 →
A049:01 →
A074:02 →
A075:01 →

A045:01
Also see
A078:01 →

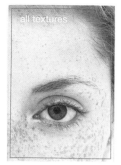
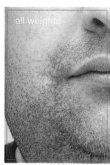
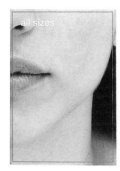
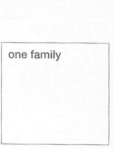

A046:01

Design: Blast

Title: One Family

155 x 113 x 30mm

68 pages

1999

United Kingdom

Produced as a promotional paper sample for
Curtis Fine Papers, this package comes as
a series of four A6 leaflets which are held in a
slipcase. This, in turn, is packaged in a white
corregated card box for postage. The graphic
treatment – a square keyline box with the
title positioned top left – is repeated on the
front of each element to maintain consistency.

The covers for each of the four books play
with the terminology used within the paper
industry – size, colour, weight and texture –
and use an approriate model's face for each
term. Each cover then reveals a quarter
section of the face, enabling them to be
reassembled to form a complete face.

A046:02

Design: SEA

Photography: Richard Green

Title: London: Cloudy –

Graphic Textures

200 x 155 x 15mm

52 pages

1998

United Kingdom

A paper sample disguised as a photography
book, 'London: cloudy' is a 52-page French-
folded book featuring photographs taken by
Richard Green of the skies over various parts
of the country. The book works its way
through the range of colours and textures
available in the range, and is interspersed with
perforated tear-sheet swatches of the stock.

The book is posted in a white cardboard box,
which has 'Graphic Textures' and a logo
printed on the front by means of a series of
needle-punched holes, a system seen more
commonly on the side of industrial cardboard
packaging, used mainly for serial or part-
number information.

A046:01
Also see
B055:01 →

A047:01
Design: SEA
Title: Substance Invite
218 x 141 x 12mm
62 pages
1999
United Kingdom

This is an elaborate private view invitation for a photographic exhibition curated by the well-known fashion photographer Rankin. The exhibition featured the work of six up-and-coming photographers, each of whom is represented within the invitation.

The invitation comes in a white clam-shell hinged box, and the exhibition details are foil-blocked in yellow and clear-varnished on the front cover. Inside is a single sheet of clear polypropylene printed on both sides with the private view details. Also in the box is a set of six concertina-folded sheets, one for each of the photographers.

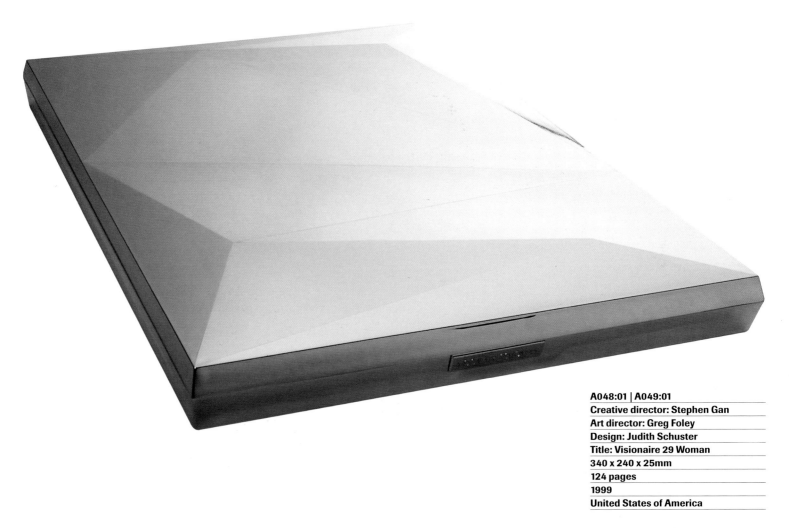

A048:01 | A049:01
Creative director: Stephen Gan
Art director: Greg Foley
Design: Judith Schuster
Title: Visionaire 29 Woman
340 x 240 x 25mm
124 pages
1999
United States of America

The outer packaging of this issue of Visionaire is constructed from injection-moulded plastic in highly reflected silver. The outer form is sleek and very angular with several different chiselled planes. The title is discreetly embossed on the front clasp. The whole package looks like a cross between a chrome-plated Stealth bomber and a Gucci make-up compact. As one opens this hard, angular construction a soft blood-red flocked cover is revealed with a coarse halftone reproduction of a nude by the photographer Nick Knight.

The rest of the book is relatively straight-forward, comprising photography, drawings, illustrations and text by various high-profile contributors, all on the general theme of 'Woman'. However, the book is punctuated at various intervals by four-page sections printed onto a heavy weight of cast-coated stock. These spreads show the same shot by Nick Knight as used on the cover, this time in full colour. Each spread reveals a cross-section of the nude, the first spread her head, the next her chest etc.

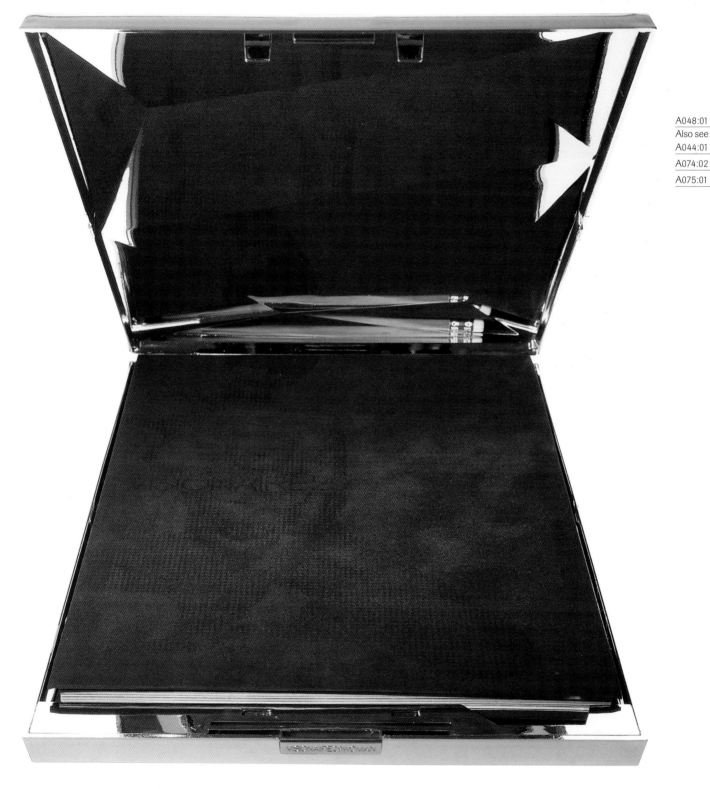

A048:01 | A49:01
Also see
A044:01 ←
A074:02 →
A075:01 →

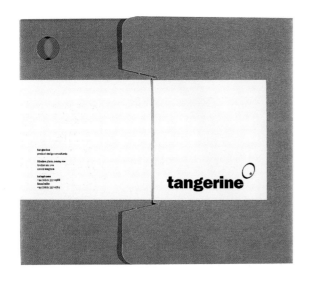

A050:01
Design: Union Design
Title: The Tangerine Book
205 x 235 x 17mm
64 pages
1995
United Kingdom

This book, which is featured in more detail on B072 and B073, is packed and sent in a robust manilla cardboard box. However, the box has been specially made to incorporate a small circular hole which reveals a flash of the front cover of the book.

By dissecting the outer protective packaging to reveal the book inside, an interesting contradiction is created, the cardboard box almost becoming an integral part of the book.

A050:02|03
Design: KesselsKrammer
Title: do Future
180 x 105 x 8mm
144 pages
1999
Holland

'do' is the creation of the Dutch advertising agency KesselsKrammer, and was conceived as a productless brand. The company produces occasional publications about this conceptual brand; this small, simple book is one such example. 'do Future' is an interesting example of a coverless book for the productless brand.

The cover is a shrink-wrapped piece of polythene with the title screenprinted onto the front. Revealed below the clear polythene is the guts of the book, without cover, spine or title page. From the outside the content looks like a featureless academic paper, and yet the cover is radical. Once the plastic has been ripped the cover is destroyed, but the contents are accessible. Inside the book are a series of surreal essays and statements designed to look very conventional, with the exception of various handwritten notes and amendments to the tract.

A051:01
Design: The Attik
Title: Radioactivity Warning
385 x 250 x 17mm
74 pages
ISBN: 0-9534606-0-6
1998
United Kingdom

By housing this unusually shaped brochure in a more standardised slip-case the designers have managed to overcome the inherent problems of a non-straight-edged book.

The cover of the brochure is made of clear polypropylene with a silkscreen image printed in a translucent ink to give a sand-blasted appearance. Inside, a series of 3mm circular holes are drilled through the pages to indicate the different sections.

A050:01
Also see
B072:01|02　　→
B073:01　　　→

A050:02|03
Also see
A071:01|02　　→
B048:01　　　→
B049:02　　　→
B057:02　　　→
B075:01|02　　→

A051:02
Design: The Attik
Title: (Noise) 3
360 x 275 x 17mm
124 pages
1998
United Kingdom

The third volume of the periodical Noise published by the globally present design practice The Attik. The book itself is a fairly conventionally produced piece, perfect-bound but featuring an array of special print processes, laser-cut, metallic inks, high-gloss inks, foil-blocking, various stocks etc.

The packaging of this book is really what sets it apart. Two sheets of metal have been punched, moulded and formed to create a three-dimensional container into which the book is placed. However, for all its implied industrial appearance, these two sheets are held together with just four small tabs of velcro in each corner. The rivets are nothing more than decoration.

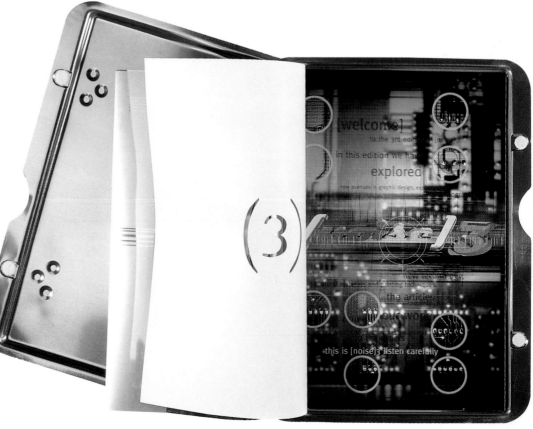

03_Formats

At the end of the 19th century William Morris's conception of the ideal book format was organised around some basic architectural principles. The kerning and tracking should be small. The font ought to be delicate but no smaller than Pica. The text should be properly set in the page, allowing for a decent size margin on all sides. Ideally the book should have handmade paper. But given the general lack of good-quality paper at the time, the type of paper should be functional rather than suggesting 'luxury'. And surprisingly, the most user-friendly books are not small, but rather big portfolios.

As far as 'ornament' is concerned, he writes that it "must form as much a part of the page as the type itself, or it will miss its mark, and in order to succeed, and to be ornament, it must submit to certain limitations, and become architectural; a mere black-and-white picture, however interesting it may be as a picture, may be far from an ornament in a book; while on the other hand, a book ornamented with pictures that are suitable for that, and that only, may become a work of art second to none, save a fine building duly decorated, or a fine piece of literature."

Morris's account is intriguing. Writing at the end of the 19th century, his formalist approach seems to pave the way for modernism. Yet in other respects Morris's evaluation of the perfect book format belongs to a much older tradition. A properly produced 'picture-book' may become a work of art, but in the hierarchy of art it follows behind architecture, and ultimately, literature. In this respect Morris reflects the 'bookist' prejudice which dominates the psyche of English criticism to this day. The values and criteria of 'the book' are applied to every genre of creativity, whether it's cinema, TV, popular music or art. The conflict between high and low culture was resolved, and high culture came out on top. This is simply because there's plenty of coverage of cinema, music and TV; the values of the book, such as narrative, are still being applied. (If this is true, Marshall McLuhan would have argued that it's a function of the centralising British state, that was English in all but name. Literary values encourage linearity and homogeneity.)

And this is why Morris can write so glowingly about the 'picture-book', allowing it to approach the status of art but only by its similarity to the content of ideal books, literature. "The picture-book is not, perhaps, absolutely necessary to man's life, but it gives us such endless pleasure, and is so intimately connected with the other absolutely necessary art of imaginative literature that it must remain one of the very worthiest things towards the production of which reasonable men should strive."

The 'picture-book' is not absolutely necessary. But it gives us hours of pleasure. And it's a bit like literature. So it ought to be part of any reasonable culture. It has a purpose.

It's not frivolous or throwaway. Though what's ultimately fascinating about Morris's essay is the title 'The Ideal Book'. The title is Platonic. Even if it is not possible, The Ideal Book with its ideal format is literally an ideal which can guide reasonable men.

Morris's description of the Ideal Book is analytical, thoughtful and reasonable. But the very concept of the Ideal Book, far from being reasonable, is in fact a fetish dressed up as philosophy. And there is nothing wrong or unusual about this. The book is a fetish object. For the man of letters it stands for civilisation. The book is a medium which stands for a certain way of ordering things. But at the beginning of the 21st century more unusual book formats are becoming more common.

Take, for example, the two questions posed by the new media folklorist Nicolas Negroponte. What costs less than $2 and takes up less space than one millionth of a cubic inch? And what costs more than $20, weighs over a pound and is bigger than 50 cubic inches? The answer is the same thing: Negroponte's book, 'Being Digital' – except the difference is that one version is stored on an integrated circuit and the other is published in hardback.

Until ten, perhaps even five years ago, the format of the book was considered as natural as genetically unmodified food. What's remarkable about the book format is that little has changed since Gutenberg. The materials and mechanics might have changed, but the essential interface of the book format hasn't changed. As Negroponte argues, "The art of bookmaking is not only less than perfect but will probably be as relevant in 2020 as blacksmithing is today. And yet books win big as an interface medium, a comfortable place where bits and people meet. They look and feel great, they are usually lightweight (lighter than most laptops, relatively low-cost, easy to use, handsomely random-access, and widely available to everyone). Why did I write a book? Because that is the display medium my audience has today. And it is not a bad one."

But the emergence of the internet as a popular medium changed all of that. Our reading habits have changed. Our instinctive coordination of handling and reading have been reprogrammed. The way we look at images has changed. Book formats that might have once been considered eccentric and inscrutable seem less forbidding and more suited to senses that have been re-wired by new technology.

And it's fair to say that some elaborate formats of catalogues and brochures once seemed like the products of a designer's indulgence. But now unusual formats are often content maps, adding another dimension to the content or else offering some perspective on the content.

Take the unusual format of 'One Woman's Wardrobe'. The catalogue for an exhibition of fashion clothes at the V&A Museum is an example of a book format that works. It's not

because the catalogue folds over and becomes a handbag. At one level it seems that the form and content don't quite hang together. Who would put 'clothes' in a 'handbag'? But that misses the point of Area's design. The collection shown in the V&A belongs to an era of haute couture that now only exists, if at all, in name only, at the seasonal pantomimes in Paris, Milan and London.

For while the exhibition itself is a history of fashion styles shown through an individual's taste, the format of the catalogue highlights the fundamental logic of contemporary fashion. Area's design unlocks the liquid economy of fashion. A book that becomes a bag demonstrates the fact that in the fashion world all signs are exchangeable: black is the epitome of fashion one year, and next year it's brown. In this way fashion itself is a model of postmodern societies and culture without absolute standards of value. Fashion is no longer a question of style, or look, or aesthetic. It functions according to semiotics, according to the logic of signs. What's important in fashion is not the cut or the tailoring. It's what you communicate by wearing certain clothes or matching different genres.

Another way of looking at this is that in a postmodern economy and culture what is being circulated is not content but information. Bits. Area's design of a brochure for avant-garde fashion designer Koji Tatsuno deploys a similar concept. The plain white box doesn't contain any trace of the clothes actually made by the designer. Instead there are cards displaying references and inspirations for the clothes as if the clothes themselves are simply momentary punctuations of a Koji Tatsuno freeform drift of ambient ideas and signs.

The fact is that the logic of fashion is the closest cultural equivalent to the way commodities and information circulate in the economic sphere. Area's design of 'One Woman's Wardrobe' literalises the notion of content by transforming the catalogue's images and commentary into the contents of a bag. In the world of fashion which has an economy of pure circulation ("Black is the new brown", "Neoprene is the new Lycra", "Long is the new short") content can only be artificially produced.

If Area's design neatly packages what is truly at stake in fashion, formats such as that for 'One Woman's Wardrobe' highlight the changing conventions of reading. The protocols of looking and reading used to be quite simple. You turn the page. You would follow the page from left to right. In the year 2000 looking and reading are about scrolling down, opening windows, pointing and clicking. In your mental pop-up window the word 'interactive' appears.

Writing in the early 90s, when electronic publishing was still in its infancy, science-fiction writer Bruce Sterling wrote that "Electronic text lacks the ritual, sensual elements of print publication… convenient stopping places, an impending

sense of completion – what one might call the body language of the printed text. The loss of these sensory clues has subtle but profound effects on one's dealings with the text."

The variety of book formats now produced reflects the massive technological revolution of the last decade. New technology allows for the cheaper production of more elaborate kinds of books. But the very structure of these unusual formats changes the reading and viewing experience. If you think of the conventional book as a kind of assembly line, it mirrors an older, pre-digital form of production. The reader moves from beginning to end, putting words and images together until it's completed. Take the format of the brochure for the NatWest Media Centre at Lord's cricket ground designed by Cartlidge Levene. It's designed as a showcase for this new building. But just as the building itself seems to float in space over the cricket ground, so the catalogue itself is unbound. Perhaps a decade ago the 'body language' of the book might have been unsettling and awkward for the reader. The lack of binding and thick board cover, which is sliced, might once have communicated fragility. But, partly because of things like the internet, we have become used to navigating our way round publications and the experience of ephemeral communications that can disappear at the click of a mouse.

If, as Sterling suggests, electronic texts have changed the rituals of reading, a catalogue like the Lab-designed inIVA Review takes advantage of our changing experience. The format of the traditional catalogue is abandoned in favour of a series of posters wrapped in a six-page folder cover. The catalogue is something that you can dip in and out of. Though each poster with its commentary is numbered from 1 to 12, there really isn't any reason why you should choose to read the catalogue in any given order. The formal unity of beginning and end is abandoned in favour of a cut-and-paste approach to reading. As Bruce Sterling identifies in the electronic text, "when you are wrapped in the utter immediacy of an electronic text, the very idea of a 'past' is suspect. Instead, you save your mental energy for the deluge of incoming data still lurking there invisibly at the edge of the screen."

Likewise these new experimental formats no longer seem so odd or unusual in the way they ignore older conventions and protocols of reading. Turning a page used to be a physical and psychological means of measuring time. The catalogues and brochures on the following pages create their own technologies of reading and looking. Though William Morris may have been a forerunner of Modernism, his vision of the Ideal Book is built around a sense of time and space that is slowly disappearing.

A054:01
Also see
A062:01|02 →

A055:01
Also see
A063:02 →

A055:02
Also see
A059:01|02 →

A055:03
Also see
A058:01|02|03 →

A055:01|02
Design: John Crawford +
Nick Thornton-Jones
Title: Ghost Menswear
206 x 297 x 46mm
28 pages
2000
United Kingdom

This book was commissioned to launch a new menswear range for the fashion label Ghost. It was decided not to show the collection on the catwalk, but instead to invest more money into a lavish catalogue.

The book, although only 24 pages in length, has a great bulk, 46mm. This was produced by bonding every page of the catalogue to a sheet of 3mm board to create the illusion of a very solid, heavy block. The edges of the board have been printed black to match the covers.

The collection is shown as a series of cropped video stills, which gives the content a sense of urgency in contrast to the monumental calm of the exterior. The pages are printed on a semi-gloss stock which again helps to increase the contrast between inside and outside. The book is bound by just a cloth bookbinder's tape on the outside edge, which makes the book somewhat more delicate than one would imagine.

A058:01|02|03
Design: Lab
Title: 04/97/inIVA Review/
297 x 210 x 12mm
12 x A2 posters
1997
United Kingdom

This annual review for the international arts body inIVA was created as a series of twelve A2 posters folded down to A4. The posters are wrapped inside a six-page folder cover.

The posters are printed on a cast-coated stock (paper which has a very high-gloss sheen on one side, while the other side is uncoated and rough). Each poster is printed in just two colours, and incorporates a series of articles and essays. Experiments with different typographic variations are used on each poster, creating interesting and almost abstract works.

A059:01|02
Also see
B030:01|02 →
B034:01-05 →
B035:01|02|03 →
B039:01|02 →

A059:01|02
Design: Cartlidge Levene
Title: NatWest Media Centre
Lord's Cricket Ground
260 x 215 x 7mm
32 pages
2000
United Kingdom

Created to commemorate the completion of the new media centre at Lord's cricket ground in London, this book was produced as a set of two separate sections. One section contains a collection of photographs showing various stages of construction of the new building, while the other contains background information about the project. Both sections are folded but unbound. These two sections are loosely contained within a 3mm-thick board cover with a diagonally sliced opening. The angle of the cut is along the same axis as the glass panels on the cover photograph, with the top edge rounded to reflect the curved nature of the new architecture.

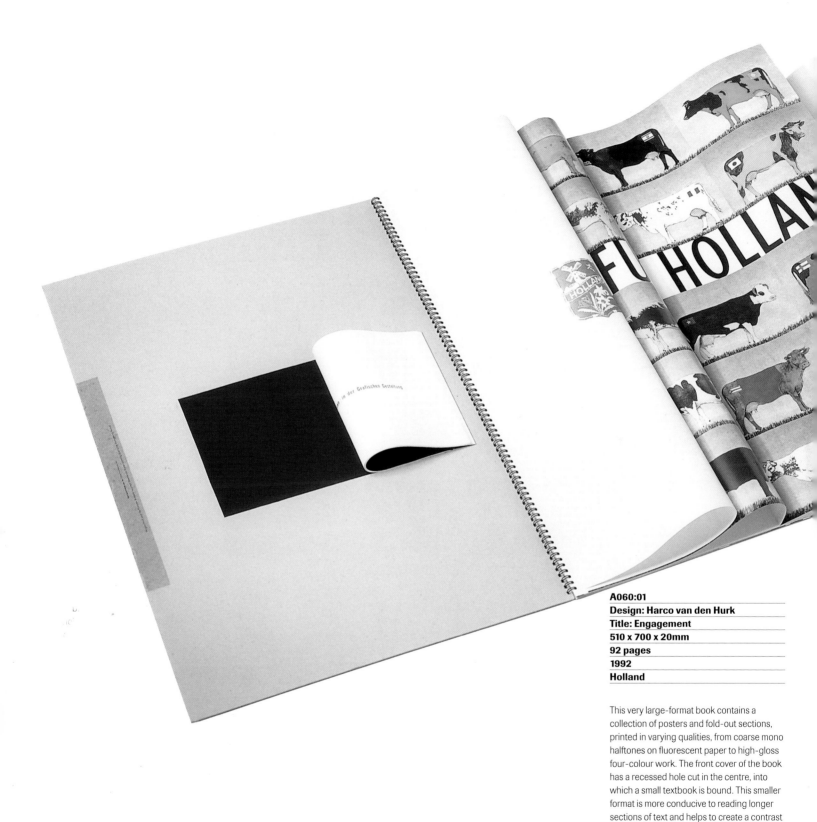

A060:01
Design: Harco van den Hurk
Title: Engagement
510 x 700 x 20mm
92 pages
1992
Holland

This very large-format book contains a collection of posters and fold-out sections, printed in varying qualities, from coarse mono halftones on fluorescent paper to high-gloss four-colour work. The front cover of the book has a recessed hole cut in the centre, into which a small textbook is bound. This smaller format is more conducive to reading longer sections of text and helps to create a contrast of scale to the main bulk of the book.

Large-format books seldom have vast tracts of text, but by binding a smaller text-heavy book into the cover a more intimate reading style is created.

A061:01
Design: HGV
Title: Size Doesn't Matter
40 x 140 x 6mm
24 pages
1999
United Kingdom

A061:01
Also see
B031:01 →

A promotional brochure for a PVC company
takes the shape of a series of rulers, all
bound by a single binding screw, allowing
each page/rule to be fanned out like a
sample swatch.

Each page has a pun, either verbal or visual,
about measuring and rulers such as, "rules
are made to be broken", or "the rule of
thumb". A variety of different PVC samples is
used and shows the quality of print possible.

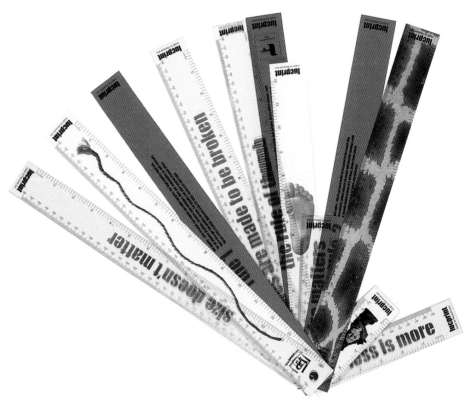

A062:01|02
Design: Area
Photography: Toby McFarlan Pond
Title: One Women's Wardrobe
594 x 440 x 6mm
50 pages
ISBN: 094883525-7
1998
United Kingdom

This large-format catalogue, produced to accompany an exhibition held at the V&A Museum in London of Jill Ritblatt's collection of historical fashion pieces, is made more manageable by the clever way in which it can be folded in half and clipped together with press studs to form a 'handbag'.

The catalogue itself is printed on a special plastic sheet that looks and prints like paper, but is tearproof, light, flexible and delicate. The covers are made of polypropylene, with the back cover enlarged to include the carrying handles and press-stud fastenings. It is bound with a set of four screws with polypropylene washers. The screw slots are carefully elongated to allow for gain as the catalogue is curved and folded, to ensure the pages do not get creased.

The main body of the catalogue features essays and still-life photography of a selection of pieces, while at the back is a large fold-out section featuring a full set of pack shots of every dress and accessory featured in the collection.

ECHOES OF SWEET NESS

A063:01
Design: The Partners
Title: Silk from France
210 x 148 x 3mm
16 pages
1997
United Kingdom

The title of this paper sample booklet for ISTD Fine Papers' Parilux range 'Silk from France' is used as a theme for the photography of a model wearing various elaborate dresses made from Parilux paper. The dresses are reminiscent of the constructivist theatre costumes designed by Oskar Schlemmer in the Bauhaus during the 1920s.

The cover section is of a conventional format and shape which helps to exaggerate the constructivist angles of the internal pages. As each page is of a different size and shape, the compositions on the spreads evolve as the pages are turned.

The booklet is bound with singer-sewn thread. This is then coloured to match the lime green and magenta of the end pages.

A062: 01|02
Also see
A063:02 →
A074:01 →
B057:01 →

A063: 02
Also see
A062:01|02 ←
A074:01 →
B057:01 →

A063:02
Design: Area
Title: Koji Tatsuno
306 x 218 x 22mm
32 pages
1990
United Kingdom

This is an unusually formatted brochure for an avant-garde fashion designer. The brochure comes in a plain white card box with the designer's name and date printed on the spine. With the box lid removed the brochure is revealed as a series of oval cards set in a mauve-coloured vacuum-formed plastic tray.

The cards reveal nothing of the designer's collection of clothes, but are designed as an insight into his references and inspirations for the collection. Printed on various stocks, including cast-coated boards and clear sheets of acetate, the cards build up into a mood board of inspiration.

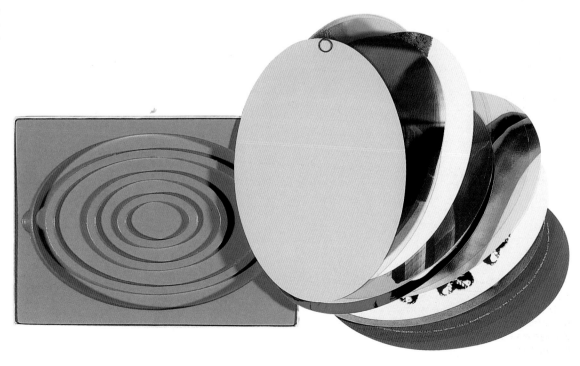

04_Materials

The Missing Voice (Case Study B) > > > > > > >

There are some staples of modern life. Pizza delivered lukewarm. Remembering to save your work at the very moment your computer crashes. And the idea that books and magazines will never end up in the dustbin of history because of their tactile quality. Even the smartest people go all touchy-feely and romantic when asked about the material quality of the book. In the response they elicit, books are exactly like the Queen Mum.

But the material used in books and brochures is fairly standard stuff – paper. Occasionally people get all Proustian about the smell of the ink or the crinkle of the paper and the memories they evoke. In the language of new media, paper is just a particular type of platform, or delivery system. Paper as an information platform will disappear if book buyers are presented with something easier such as the current developments in virtual pages.

When it comes down to it, consumers as a group aren't particularly sentimental. The day you can sit on the tube or the bus and scroll through a book, magazine or newspaper display through your spectacles with a screen display, will be the day when paper is dumped as a mass medium.

If the traditional three-dimensional book survives technological evolution, it will be because its materials may change according to its content. As production processes become cheaper, customised books will increasingly be an option. Already, creators of books are using materials to communicate an experience which adds to, or transforms, the content in some way.

Encased in a specially built white polystyrene box, Catalogue/Annette was a set of two books produced for Welsh artist Melanie Counsell. You open the box and inside there's the black mottled cover of 'Annette' – except as you pick it up you realise there are no covers and the front page is in the same delicate 'rolling-papers' thin material. Look inside the box, and there appears to be a false bottom. But in fact it's the white mottled cardboard cover of 'Catalogue'. It melds seamlessly with the polystyrene surrounding it. Light and dark.

'Catalogue' offers a history of Melanie Counsell's work, while 'Annette' is a book project in itself. They were a collaboration between the artist, the gallery, the art-project body Artangel and designer Phil Baines. Baines is a freelance graphic designer who works on book projects, but also has a particular interest in typography, having produced typographic work for TV commercials and his self-published letterpress, SToneUTTERS. As he explains, "My role was limited to 'Catalogue'. 'Annette' was really Melanie's artbook I suppose. All sorts of ideas about packaging were discussed and Robin Klassnick, director of the gallery, found this guy who was able

to do polystyrene boxes and would take both books. There was no other way of physically binding the two things together, they are so disparate, and the concept is disparate. Sleeves were discussed. But as much as anything else it partly came down to price and partly what you could get that wouldn't damage 'Annette'. The size of it didn't really allow for a hardcover, and Melanie didn't want a hardcover. It just happened that the format for 'Catalogue' would work with the size of images and pictures that Melanie was already working with for 'Annette'."

Both books were created with different purposes and were constructed with different communications in mind. But what holds them together physically, as Baines points out, but also conceptually, is the material. While 'Catalogue' with its solid paper is, in a non-pejorative sense, a prosaic account of an artist's career, 'Annette' is an impressionistic book about the representation of experience and the tissue of memory. The almost transparent paper allows images to appear over others, blurring and blending. While 'Catalogue' offers clarity, 'Annette' communicates density and fragility. 'Annette' is the negative of 'Catalogue'. 'Catalogue' unfolds in a linear fashion, opening up the space of her career, 'Annette' is an exercise in the compression and condensation of space.

Baines' own training as a graphic designer emphasised the importance of materials. "I think if you do books you have to be interested in materials. Some of that I learned from Richard Hollis. I worked with him years ago on a job for the Crafts Council. I learned an awful lot from Richard about use of materials and making money go a long way, and Richard's very good at those sort of things. And also, because I did a lot of letterpress at college I was always aware of materials. Because rather than just setting type I was printing it as well. You had to choose what paper to print on, which gives you a better sense. It is quite easy to forget the physical reality of books when you are working on the computer. It's there and you scroll through and you are so used to seeing the stuff on white laser-writer backdrop, but actually the paper is very important. 'Catalogue' is just plain art paper, but the weight is quite important so that there's no show-through. But then the cover's quite important. It's got that textured cover that matches 'Annette'. It's kind of a bit corny on its own, but somehow the whole package works."

Indeed, the boxed set probably ought to look kind of ugly and feel cheap. The petroleum-based polystyrene is the definition of packaging. It's not eco-friendly biodegradable. Even McDonald's cut back on its styrofoam packaging in the early '90s. You throw it away when you take your sound equipment or TV out of its box. It is 95 per cent air. Polystyrene houses most durable consumer goods.

But in this case polystyrene has an aesthetic. Because of the value placed on what's inside, and because of the artefact contained within and the delicate nature of 'Annette', the functional protective quality of the material actually becomes decorative. To say that it is just decorative ignores the transformation of the functional. What the polystyrene does, both literally and aesthetically, is to frame the books. It gives the two books with different purposes and subject matter a sense of place, of being placed.

This concept of place is also behind the use of unusual materials in a book designed by olly.uk.com for Levi's Vintage Clothing. Over the last few years the company, whose name has become synonymous with jeans, has suffered a dramatic decline in sales. Faced with stiff competition from manufacturers and retailers like Diesel, Gap and Tommy Hilfiger's, sales of Levi's jeans dropped from $7.1 billion in 1996 to $5.1 billion in 1999. The prime candidate to take the fall was the company's CEO who, critics charged, was more interested in implementing management theory than actually selling jeans. But a more likely candidate was the market itself, which had fragmented from the heady days of the '80s when everyone fantasised about Nick Kamen stripping off his 501s in the launderette.

Take this remarkable sales figure for example. Some suggest that as much as 75 per cent of American men own a pair of Levi's Dockers. But if the Levi's name begins to get associated with a younger generation, how are the Dockers buyers going to feel about wearing Levi's? One way of doing this is by launching a line of Levi's jeans that don't actually carry the Levi's name, such as Red Line. Another way is through designing a product whose low profile and lack of publicity adds cachet to the brand. Levi's took this route with their Vintage Clothing, a range based on original materials and original finishes. They copied a pair of jeans that was found in an old mine. And instead of taking out adverts in fashion magazines they commissioned Olly Walker to produce a book. It was aimed at buyers and the fashion press.

As Walker explains, "There were only 500 numbered editions ever made. They were put out to the top fashion press throughout the world. They don't advertise Vintage Clothing. It's very much to do with an underground feel. Which is why they invited all the artists to customise the denims, which is a secondary part of it. It also adds publicity to it, but it's all supposed to be found out through underground, through word-of-mouth. The jeans are only sold in a few shops such as Duffer's, Brown's Focus in South Molton Street, and a couple of other places, one in Manchester, one in Nottingham maybe, then Collete in Paris and a couple of shops in Tokyo. It's all about being found."

The original template of the jeans which was found was reflected in the material and content of the book, which uses the aesthetic of the 'found object'. As Walker explains, the concept behind the book is that it's a kind of diary or travelogue, and like Kerouac's 'On The Road', the destination isn't important. It's what you find on the way. "The way in which I put the book together and the materials that were used was all about using very basic kinds of materials and putting them together in a very solid way. Using thick board and held together with the correct bookbinding tape. Really simple but incredibly strong. I finished it in loose-leaf denim with patches applied which were borrowed from the collection. They used these patches which were worn by most students and beats in the '60s. Within that, the layout was all to do with putting over an 'On The Road' feel, as if I'd kept a diary of where we'd been. All the bits and pieces, all the notes on the description of the product were almost as if we'd discovered them on the way and hacked them out on bits of paper and put them on layout. In fact that's exactly how we did it."

The dust jacket was made out of original materials. They were ripped and slightly torn. Inside there was a scratched-up white Levi's Iron logo. It wasn't just the material that was odd, but the kinds of images were a journey on the open road for Levi Strauss. Walker explains, "I'd done one before where I'd illustrated it all for them. I've managed now through working a couple of times on this to push them and persuade them that we can go out and shoot 'lifestyle' like we did for that. That was the first ever time they'd bothered taking a photoshoot, apart from doing a flatshoot with just basically laying the product flat on a white space almost as a record. This was the first time. I kind of persuaded them down this whole route of how to do this. I held their hand down that route to some extent."

It is fascinating the extent to which jeans are often sold around myths of origin. The 'original jeans', worn by cowboys, miners, farmhands, railroad workers. The jeans that built America. Jeans are the clothes of the frontier myth. It's no surprise to see Levi Strauss trying to re-invent their jeans in the minds of fashion journalists and kids on the street as the jeans of the storytelling beat culture. What is interesting is the belief Levi Strauss had in the effectiveness of 'the book' in communicating this idea.

A066:01
Also see
A045.01 ←
A078.01 →

A067:01
Also see
A069:01|02 →

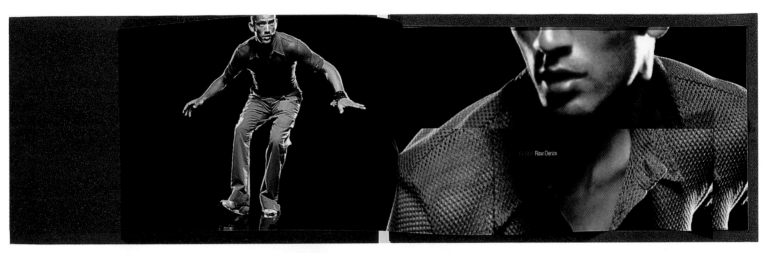

A068:01|02
Design: Jaq La Fontaine
Title: G-Star Raw Denim s/s 2000/01
250 x 415 x 40mm
60 pages
1999
Holland

For its Spring/Summer 2000 brochure the
Dutch clothing company G-Star produced an
elaborate promotional sales brochure. The
brochure is packaged in a black high-density-
foam box, which is an integral part of the
brochure cover. The box lid is glued to the
front cover, and the back cover is glued to the
bottom of the recessed box. When the box/
cover is closed the lime green card spine of
the brochure remains visible, forming the only
external indication as to the content.

The brochure itself is bound by very large
industrial staples (the type used on packing
boxes), which are punched through the bulk
of the book from front to back. A very high-
gloss paper is used throughout the brochure
as a contrast to the rough, porous surface of
the black foam.

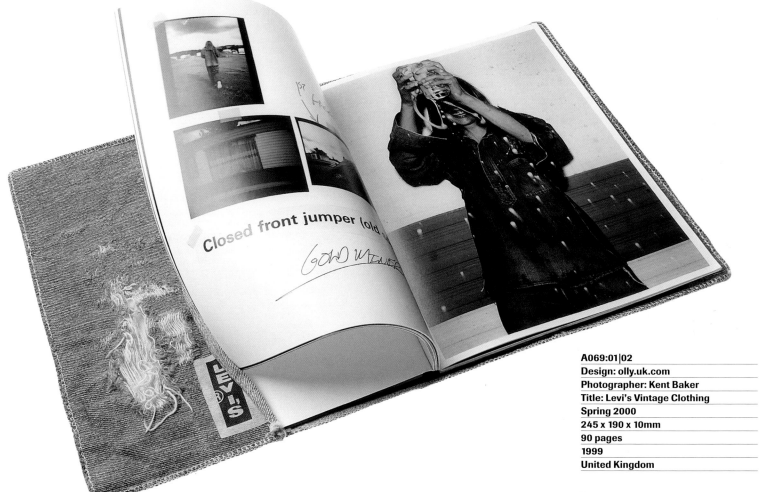

Closed front jumper (old

A069:01|02
Design: olly.uk.com
Photographer: Kent Baker
Title: Levi's Vintage Clothing
Spring 2000
245 x 190 x 10mm
90 pages
1999
United Kingdom

This book for Levi's vintage denim comes in its own distressed denim dust jacket. The book is a sewn section case-bound volume, the cover has a discreet Levi's logo tab running close to the spine on the front.

The dust jacket clearly illustrates the content of the book, which is a series of images of secondhand and old Levi's in action, shot on various locations across America. Each cover went through a rigorous process of ageing and distressing before it reached the desired state. Then the odd sewn badge was added afterwards. Every cover for this book is by its very nature a unique work.

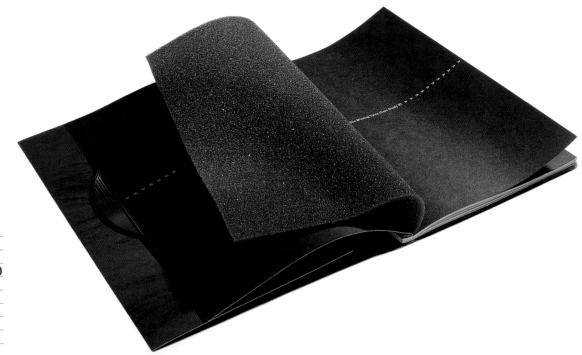

A070:01|02|03
Design: Mark Diaper
Artist: Janet Cardiff
Title: The Missing Voice (Case Study B)
240 x 170 x 12mm
72 pages
ISBN: 1-902201-07-8
1999
United Kingdom/Holland

'The Missing Voice' is a beautifully produced catalogue for an event organised by Artangle and the Whitechapel Gallery in London's East End. The catalogue contains an audio CD on the inside front, held in place with a small foam button. The catalogue has a very tactile quality – as one holds it the card cover feels padded and soft to the touch. This is achieved by the inclusion of a thin sheet of black sponge bound into the inside front and back covers. These sheets of sponge also act as a form of protection for the CD on the inside front cover.

The catalogue is singer-sewn, which is a binding method where a sewing machine is used to bind all the pages together, sewing from front to back through the catalogue.

After the introductory section of the catalogue the main image section is French-folded, printing black-and-white images on the outside and colour on the inside. The effect is increased by having the images fading in and out, allowing the counterimage to become more visible.

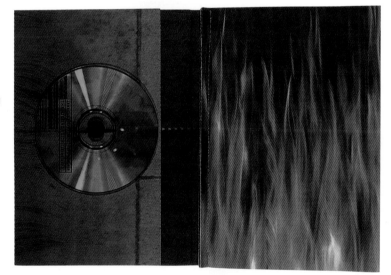

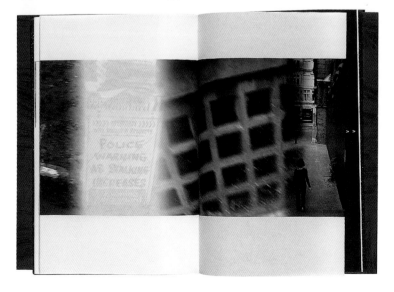

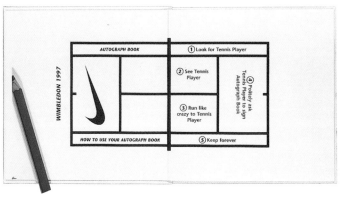

A070:01|02|03
Also see
B054:01|02 →

A071:01|02
Also see
A050:02|03 ←
B048:01 →
B049:02 →
B057:02 →
B075:01|02 →

A071:01|02
Design: KesselsKrammer
Title: Nike Autograph Book
125 x 125 x 8mm
14 pages
1997
Holland

As a fun give-away Nike produced this little autograph book for Wimbledon in 1997. The covers of this concertina-folded booklet are covered in green felt, as a reference to the lawns. The booklet is strapped together with a black elastic 'headband' with the title printed on the front. A handy autographing pencil is slipped inside the elastic to complete the kit. Inside are useful tips on how to get the various sporting stars' autographs.

A071:03
Design: Ontwerpbureau 3005 /
Marc Vleugels
Artist: William Engelen
Title: Intermission no. 3
160 x 227 x 9mm
92 pages
1999
Holland

The use of tracing paper sections in this book for the artist William Engelen helps to build up and then peel away dense layers of keyline diagrammatic structures and notations by the artist.

The tracing paper is interspersed with uncoated off-white stock featuring black-and-white photography; a silk stock is used for the colour photography. The covers are made of dark grey bookbinding board mounted with colour-printed sheets.

A072:01|02
Design: SAS | Marek Gwiazda
Title: Maria Harrison Synthesis
320 x 317 x 5mm
40 pages
1998
United Kingdom

This brochure is designed for a specialist jewellery designer, who tends to produce one-off pieces which are more likely to be seen behind glass in exhibitions than worn on a daily basis. It was designed as a signed limited edition for use at such exhibitions, with the aim of showing the work both as sculptural art objects and also as functioning pieces of jewellery.

The brochure has an outer dust jacket made from soft, natural, clear PVC with the title embossed on the surface. This material gives the brochure a soft, very tactile quality which is followed through on the inside through the use of cotton papers, which again add a soft human quality to the brochure. The cover stock is the same weight as the text pages, which makes the brochure very flexible.

The text pages are interleaved with orange and yellow sheets of translucent film which filter the photographic images beneath. Each piece of jewellery is photographed in black and white, with a corresponding part of the body overprinted in process yellow; a bracelet has a hand printed over it, a necklace has a neck etc. With the coloured film overlaid the yellow print becomes invisible; as the film is lifted the full image is revealed. This technique gives the brochure a magical quality as the user interacts with the pages.

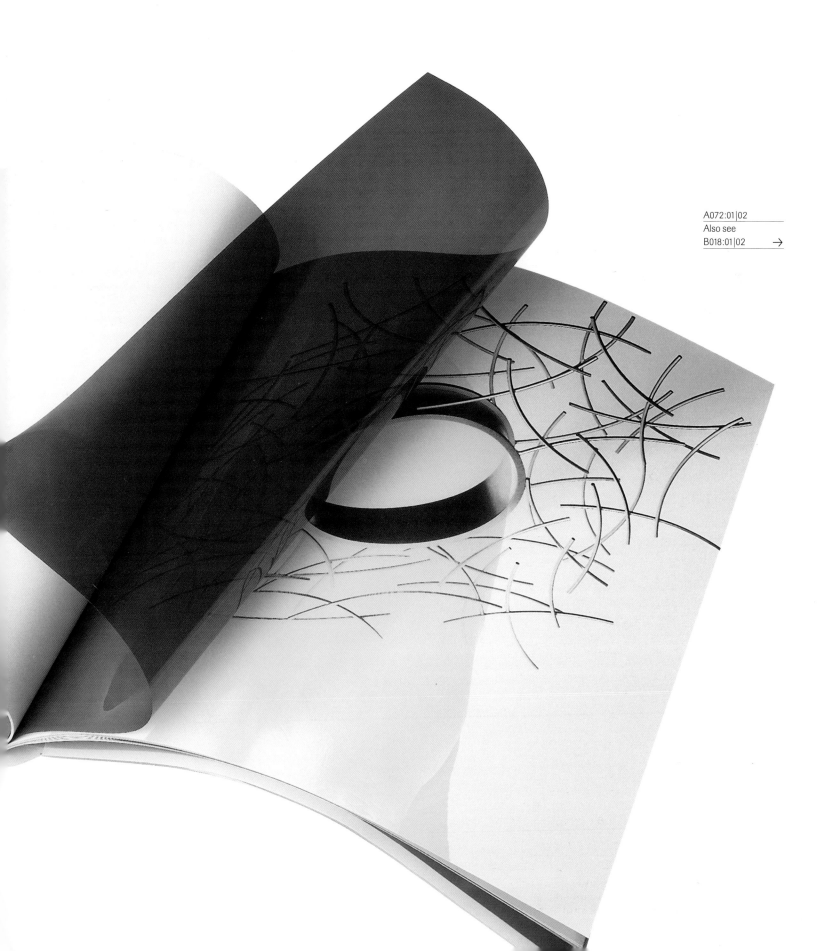

A072:01|02
Also see
B018:01|02 →

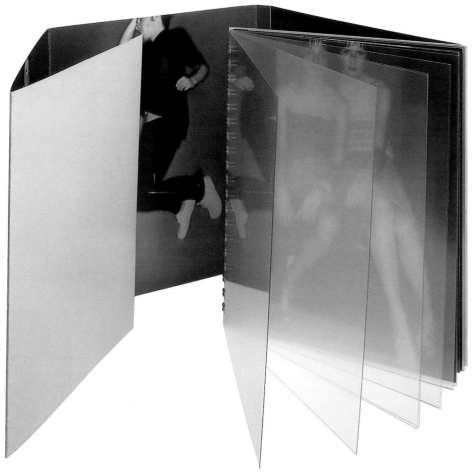

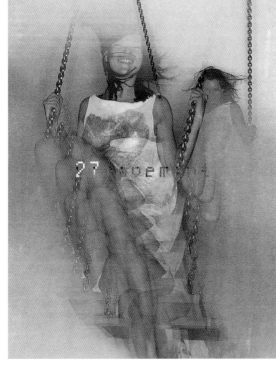

A074:01

Design: Area

Title: Paul & Joe Spring/Summer 1998

172 x 140 x 8mm

54 pages

1998

United Kingdom

An almost mirror-like quality is created on the introductory pages of this fashion catalogue through the use of 12 sheets of thin, clear acetate. As these sheets are peeled away the first page of photography comes into focus. Then after only six pages of photography, another series of acetate pages builds up to the end of the brochure. It is then discovered that further images are hidden away behind the roll-folded front and back covers.

As a result of all this additional padding the brochure has a weight and substance that turns what could have been just another leaflet into something more akin to an artist's book.

A074:02 | A075:01

Creative director: Stephen Gan

Design: Design/Writing/Research

Title: Visionaire 27 Movement

316 x 247 x 23mm

144 pages

1999

United States of America

This issue of Visionaire features a stunning lenticular cover which perfectly illustrates the subject matter. The content of the book is printed on tracing paper, with each individual contribution extending over several spreads. These build up dense, multi-layered images and work very closely with the translucent nature of the material.

Lenticular images are normally constructed from two interlaced images which are filtered through a special sheet of plastic with lens-shaped ridges on the surface. This allows one or other of the images to be viewed dependant on the angle at which the surface is held. This cover is built up of 14 separate photographs of Kate Moss on a swing which creates an almost live-action animation of Kate swinging back and forth.

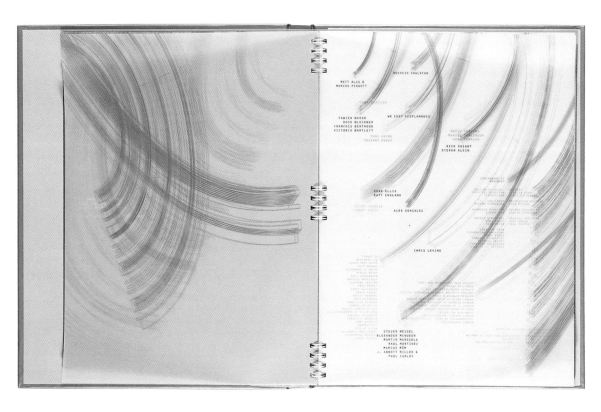

A075:02
Design: Unica T
Title: o.T.
120 x 230mm
48 pages
1991
Germany

The 'o.T.' book was created by silkscreening abstract collages onto large sheets of ridged perspex, which were then cut down to the final page size.

The resulting book forms a series of fragmented images that when bound together build up into a deep and complex whole, broken only by three divider or chapter pages printed in solid yellow. The book is wire-bound, which helps to break down the fixed order in which the book is to be 'read'.

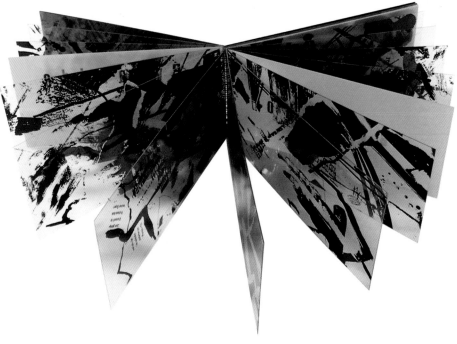

A076:01
Design: MetaDesign London
Title: Transig
297 x 210 x 3mm
24 pages
1998
United Kingdom

Confronted with the problem of tracing paper being too transparent and bible paper being too opaque, the designers' solution was to print tracing paper with a solid area of white lithographic ink over the entire surface.

The whole brochure, with the exception of the cover, is printed on French-folded tracing paper. A sequence of large black-and-white photographs is printed on the inside of the French folds, which build up into a heavy industrial mass. Fine tram lines and solid blocks of colour are printed on the outsides together with the text.

A076:02
Design: Ulysses Voelker
Title: Zimmermann
Meets Spiekermann
280 x 214 x 8mm
42 pages
ISBN: 3-929200-01-5
1992
Germany

French-folded bible paper is used to good effect on this book about the work of Erik Spiekermann and MetaDesign. The use of show-through is used to the full, showing final work on the outside and work-in-progress or supplementary work on the inside.

The cover is made of recycled board produced from roughly shredded post-consumer waste; fragments of text are still legible within the predominantly grey pulp.

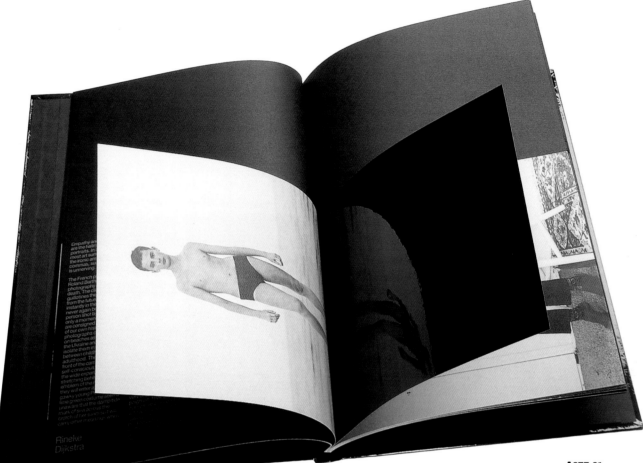

A077:01
Also see
A042:01 ←
B007:01 →
B011:01|02|03 →
B016:01|02 →
B017:01 →

A077:01
Design: North
Title: The Citibank Private Bank
Photography Prize 1999
304 x 213 x 10mm
68 pages
ISBN: 0907879551
1999
United Kingdom

The 1999 catalogue for the Citibank Private Bank Photography Prize is very black. The cover is printed in a gloss black case-binding. Inside, all the text pages are on black stock printed with grey text.

Each of the shortlisted photographers has a separate section of the book, which begins with a black page with an essay about the photographer. This is then followed by an eight-page section printed on cast-coated stock which has been cropped down to occupy only the lower half of the book. The coated side of this section is printed in solid black, with the uncoated side used to show the photographers' work. The highly reflective nature of the coated surface allows the image to be reflected back on itself. It also creates a strong contrast to the matt-black stock used for the rest of the catalogue.

A078:01
Design: Phil Baines
Artist: Melanie Counsell
Title: Catalogue/Annette
267 x 355 x 70mm
Catalogue: 72 pages
Annette: 264 pages
ISBN: 1 902201 00 0
ISBN: 1 902201 00 9
1998
United Kingdom

'Annette' is one half of a set of two books packaged inside a custom-built polystyrene box (featured earlier). The book is a 264-page volume which contains still images taken from one of the artist's 8mm films. The images are dense, grainy, black-and-white fragments; sometimes the same image is repeated over a sequence of pages, and some pages are left blank while others are entirely black. The whole book, including the covers, is printed on a very thin tissue paper, enabling the images to show through from other pages. This helps to build up a rich layering effect.

The nature of such a thin, delicate stock means the ink bleed-through to the other side creates a rich contrast between the recto and verso sides of the page.

A079:01
Art director: Gary Cochran
Packaging: Artomatic
Title: It – Experiment
188 x 188 x 40mm
32 pages
2000
United Kingdom

Produced as a special limited-edition version of the fashion magazine 'It', which is encased in a black high-density foam box. The lid is held in place by a U-shaped piece of lime green live-edge Perspex with the magazine's masthead silkscreened in white on the front.

Inside the box is a series of ten six-page concertina-folded cards, each by a different contributor.

A079:02
Design: Johnson Banks
Title: Tom Dixon – Rethink
280 x 216 x 15mm
128 pages
1998
United Kingdom

Written by the furniture designer Tom Dixon, this book is, as the title suggests, concerned with reassessing the usage of everyday objects. Taking industrial supply equipment and placing it in the home environment, Dixon created a low-cost modernist alternative to regular home furnishings. This philosophy begins with the cover of the book, which is made from two sheets of 3mm-thick MDF board which are bonded to both front and back covers, creating a ridge block.

Inside, images taken directly from industrial trade brochures of metal shelving systems adorned with boiler-suited workmen demonstrating the strength of the shelves are juxtaposed with photographs of 'lifestyle' room settings showing the same shelving system – without the boiler suits.

A078:01
Also see
A045:01 ←

A079:02
Also see
A043:01|02 ←

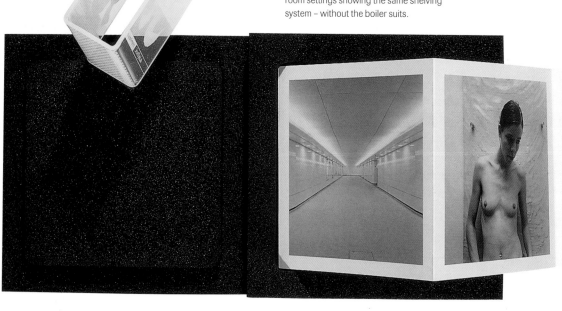

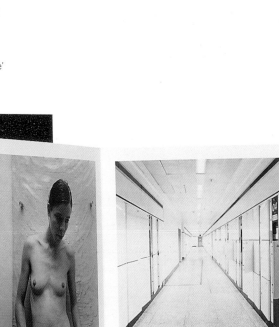

05_Printing

jorge pardo

**Introduction
by John O'Reilly**

B004:01
Also see
B012:01 →
B013:01 →

B004:02
Also see
B008:01|02 →

B005:01
Also see
B020:01|02 →
B021:01|02|03 →

In an era of image pollution, where billboards, cinema, TV, video, computer games, web sites and WAP screens all spill their visual data all over our visual space, print technology may be on the way to being a media fossil. Perhaps the revolution of Gutenberg has had its day. Or maybe print will always have a place, if only to provide the instructions for Tomb Raider 21.

Marshall McLuhan's account of the impact of print processes does seem to belong to another era, before the age of DTP. "A place for everything and everything in its place is a feature not only of the compositor's arrangement of his type fonts, but of the entire range of human organisation of knowledge and action from the 16th century on." He's completely correct in identifying the kind of thinking promoted by the evolution of print technology. Classification and rationalism were inevitable effects of print processes and the visual impact of print. And print also fostered nationalism in the image it gave to readers of their mother tongue. It engendered the values of individualism and privacy instead of the communality of oral culture.

But print technology is now mostly post-industrial. While vernacular language on the page may generate some unconscious identification with nationality, new print processes are far removed from the mechanical, assembly-line technology of the printing press. Among other things, DTP has created a decentralised culture of small businesses. And the examples in this section use techniques such as laser technology to create marks on the page. Print is created by light. As McLuhan might have said, electricity has invaded the page.

Of course you don't need state-of-the-art technology to produce interesting print. In Trans>6, an arts and media journal, Jorge Pardo and Jac Leirner use office equipment like the hole punch and the paper shredder to produce graphic effects on the surface of the page. In fact, state-of-the art may in fact be a hindrance. Sagmeister Inc.'s design of American Photography 15 features the panorama of a landscape on the three edges of the book. It is striking. However, the image bleeds onto the side of the page, producing an intrusive framing device for the photos it displays.

But one of the most extraordinary gestures in the print medium, ever, was commissioned by Dutch company SHV. It is lying on my desk in front of me. It looks like a shoe box, but the dimensions aren't right. The cardboard packaging is constructed in such a way that it suggests it is sealed. It's like one of those machines they have on aeroplanes, a black box recorder. And in a way that's exactly what it is. It's a memory machine that rewinds the history of SHV.

It took longer to build this book than it would take to erect an entire city centre complex or construct a motorway system. Five years of intensive labour went into making it. It is

2136 pages long. As the scale of the project became known and the book was talked about rumours spread, partly because the name was kept secret. And the title remains concealed. It is secreted throughout the book, disclosed letter by page-size-letter as you leaf through its pages made from 100 per cent cotton. It's called the 'Thinkbook'.

In marking their centenary SHV avoided the corporate cliché of commemorative art and decided instead to commission arguably the best-known book designer, Irma Boom. Her background is in fine art. Enrolled in art school in Enschedé and studying painting, in her third year she switched to graphic design. As she tells it, it was by chance she discovered book design. "When I was still doing Fine Art, I met this guy in the Graphic Design department, a lecturer who made me very enthusiastic. He was a design teacher. But every week he came to the school with two suitcases of books. And he just talked about books. He made me really enthusiastic. He didn't talk about the design, but more about the content, the size, very basic information."

Despite friends who argued that it would be incredibly dull, she joined a studio and became a designer. But Boom learned her trade there. "It was very practical. Mostly, I must say, people working on books tend to be 'crafty' and I don't like craft at all. Books should be an industrial thing, spread everywhere. This handmade thing which you also see when you hear of a book designer working with books is so 'crafty'. I really hate it. Everything should be made on a press; everything should be made industrially. This handmade quality I don't like at all." Which is one of the fascinating things about Boom. Implicit in her vision of books as industrial products is a kind of disdain for the preciousness of craft, the authorial hand, the artist's hand – although in the way she works and in her influences fine art plays a larger role than design.

"I am influenced by Fine Art more than design especially in the way I work. I am always working. Sometimes I have an assistant. But mostly I love to work and concentrate on my own. I don't look too much at what colleagues are doing. I get more inspiration from Fine Art. Artists like Daniel Buren, I'm really very fond of him. And John Baldessari. I like the way he uses photography, and adds things to it, like dots. I like the way he deals with photography. Those are people I really admire and look at." You can see something of Baldessari's semiotic hyperactivity in the 'Thinkbook'.

But most of all, the initial impact of her books is a physical one. They have the condensed energy of sculpture married to the fact that they are functional objects to be used. As Boom says, "I see a book as an object because it has three dimensions. It has weight, size and thickness. All the dimensions and tactility are important. If you lift a book is it heavy or is it light? I just made a book for a light company in

Austria, and it's a big book, but it's very light! The object aspect of the book is very important. Not always to start with. The book as an object emerges when things come together. It suddenly happens. It's not really something I go after, but suddenly it's there."

This object quality took five years to emerge in the 'Thinkbook'. With her catalogue for a show called 'The Spine' it took five days. The gallery didn't have much money, so all the full-colour photos were printed on one sheet. Trying to save money, Boom thought it was cheaper to print silver on the paper and then bind it together at the spine: "The artists were in the same building but didn't have much else in common other than they were in the show. They were held together by the spine. And the typography itself is like a spine."

'SHV' took five years of obsessive work. "At the beginning I worked on other projects in the evening. But for the last two and a half years, I worked on the book, day and night, seven days a week. It was like being in a dark tunnel without light." But even though Boom argues that 'the book' should be industrial rather than a craft work, as an industrial product the book would still be an old technology, like the Moog synthesiser or the electric guitar. "But," she argues, "what I think is interesting is if you go to the edge of what is possible. Like this 'SHV' book. It's not a linear book. It's not going from a to b to c. It's even more complex than a web site. You have to give it a lot of attention. It's a contemporary way of approaching a book. I once thought that books were old fashioned, and I even tried web design. But then I found out that in book design you can do so many interesting things. There are still limits to cross, to challenge. But I can imagine young designers now in schools thinking 'It's really boring!'"

As you pick up the book you notice that the side of the book reveals a picture of a field of tulips that spread from the edge over onto the right-hand margin of the page. If you look at the edge from the 'finish' of the book you notice some writing. It's a Dutch poem. This is a visual introduction to a book of secrets, with visual, verbal and material clues dotted throughout, revealed in watermarks of chinese ideograms, mirrored writing and laser-cut perforations.

The 1000 years of SHV's history is revealed in photos, official documents and internal memos. The photos are blurred as if they are a screen-grab from TV, which adds to the 'playback' effect as the book rewinds the company's history. Graphs illustrating company profit are followed by weather graphs plotting temperature as if the business climate folds over to a more general question about ecological climate. There are reflective essays on the relationship of commerce, science, art and society by businessmen, politicians and art critics. Occasionally pages ask questions such as "Is thought physical?" In short, the book is a dense sensorium of visual, verbal and tactile information. And it offers little help to readers navigating their way around.

As Boom explains, "In 'SHV' you can begin everywhere. There are no page numbers. It's a very big book but no page numbers, no index, no register, nothing. You just start somewhere and there are a lot of bookmarks in the book. And there are a lot of things to find. It's more of a journey through the history of the company rather than going from this to this. It's more about finding your way through the book. What is also interesting is that the book has different levels of reading. You can flick through the book in two seconds and you think you have seen it. But if you do it another way, you can read all the questions. And they are particular kinds of questions. There's another level of reading where you can go into the actual text. I think that the multi-layering of the 'Thinkbook' is contemporary."

And despite the dense appearance of the 'Thinkbook', it's actually quite a functional book. It is a designer's book rather than an artist's book in that it is designed to be read rather than looked at. "It's smaller than you think. It looks really big, but it's really a sort of handbook. It's large in thickness. We asked the oldest shareholder in the company to handle it. She's 90, we gave her a few sizes of books. She said, 'This book I like, it's a good size.' We thought that the oldest shareholder of the company should be able to handle the book easily. It shouldn't be awkward. She must be able to read the book because it's not a book made for the bookshelf, it's a book for inspiration, for the future. It's not a book for looking back. Work with it, it's a tool. More a tool than the kinds of commemorative books that companies usually produce to put on the shelf. That's not what we were after."

Some reviewers remained sceptical of the book, arguing that it lacked innovation and that its aesthetic qualities and philosophical tone only served to exalt the mundane act of making money. That perhaps the authors got too close to the company men who were funding it. But the book itself as a document of record begs questions. The lack of a linear narrative suggests that despite being a book about the past, does the 'Thinkbook' give up on history, on making sense of the past? Is history no more than a magical scrapbook?

Irma Boom's book is reminiscent of the heroic modernist architecture promoted by the visionary architect in Ayn Rand's 'The Fountainhead'. But whereas 'The Fountainhead' advocated the American virtues of a heroic, rugged entrepreneurialism pitted against social convention and conformism, the 'Thinkbook' offers a softer, reflective, European view of the relationship between commerce and society. The scale of the project communicates both romance and ambition, a belief at the end of the 20th century in the impact of print.

LISSINGEN –
DR FH – WHEN
INENT POSITION,
INTO CONFLICT.
N AGREEMENT.
WE'RE BOTH
:S THAT PULL A
WE CAN'T WORK
KE ROTTERDAM
N OPERATIONS,
iERMANY, COAL
NETHERLANDS.

B006:01|02
Design: cyan
Title: Tod Versuche Mich
Scardanelli Poesien
150 x 115 x 11mm
192 pages
ISBN: 3-932193-01-6
1999
Germany

This little pocket book, on initial inspection, would appear to have a fairly conventional cover: yellow typography on a white background. However, on closer inspection the white background has a luminescent glow: switch the lights off, and the full radioactive quality of the cover is revealed.

Inside the book a section at the front and back is printed in killingly bright fluorescent colours of abstract 'op art' patterns and retro photographs. Sandwiched in the middle is a 124-page text section printed on a cheap mint-green stock containing a selection of poetry.

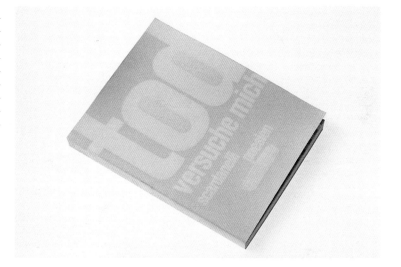

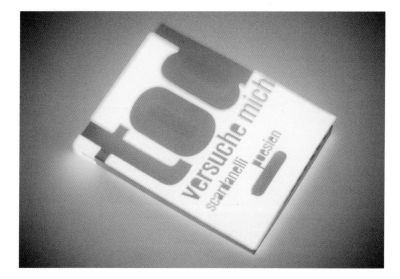

B007:01
Design: North
Title: The Citibank Private Bank
Photography Prize 2000
297 x 210 x 4mm
40 pages
ISBN: 0907879578
2000
United Kingdom

This annual photography book showcases the finalists for The Citibank Private Bank Photography Prize 2000. The book has five different covers, each one featuring one of the finalist photographer's work. A grid of small circular dots is printed white out of the image over a section of the cover. Printed on top of these white dots is a larger-scale version of the same grid structure printed in spot-UV varnish with a special gelling agent added to give the UV dots a very three-dimensional quality. The effect is heightened due to the cover being matt-laminated prior to the application of the spot-UV.

American Photography 15 presents 320 images by established and emerging photographers, selected by an outstanding jury of creative professionals from over 4,000 entries. This collection, gathered from magazines, books, promotional publications, and personal portfolios, offers an informed view of photography today, with images that resonate through their clearly original point of view. The photographers represented this year are: Michael Ackerman, Timothy Archibald, Josef Astor, Mark Arbeitman, Nelson Bakerman, Richard Barnes, David Barry, Ali Becker, Jonathan Becker, Pej Behdarvand, Bruce Bennett, Harry Benson, Howard Berman, Anuschka Blommers, Chris Buck, Richard Burbridge, David Burton, Sonja Claud Byrn, Chris Callis, Michele Clement, Anton Corbijn, Anna Curtis, Susie Cushner, Craig Cutler, Kevin Davies, Yuri Dojc, Myric Duffy, Todd Eberle, Jim Erickson, James Fee, Baldomero Fernandez, D. Hardie, Larry Fink, Bob Frame, Jim Franco, Leonard Freed, Erica Freudenstein, Amanda Friedman, Edward Gajdel, Jacques L. Garnier, Peter Gerlice, John Goodman, Lauren Greenfield, Hugh Hales-Tooke, D. Hardie, Ron Haviv, Alexei Hay, Gregory Heisler, Ethan Hill, Henry Horenstein, John Huba, Stefan Indlekofer, Sam Jones, Ed Keith, Russell Kaye, Cecil Kerr, Sean Kernan, Danny Ali Maya, Kimberly, Robert King, Antonin Kratochvil, David LaChapelle, George Lange, Michael Lavine, Annie Leibovitz, Jason Lyon, James Leynse, Matt Mahurin, Esther Mallouh, (continued on back)

B008:01|02
Design: Sagmeister Inc.
Title: American Photography 15
322 x 245 x 35mm
340 pages
ISBN: 1-886212-11-2
1999
United States of America

This annual of contemporary American photography has a very minimal cover, pure white with a band of fragmented images pulled vertically down the centre. This image contains compressed versions of the 320 images that appear inside the book. The title of the book is not even printed on the cover, but is discreetly printed on an acetate dust jacket.

By compressing every image onto the cover the tricky political problem faced by the designer is avoided when producing a volume such as this. By selecting just one image from the hundreds of photographers featured in this 340-page book there is a danger of favouritism creeping in.

Although the front and back covers remain predominantly white, the spine and three other edges of the book have absorbed a huge mass of imagery. A 360-degree surreal panoramic view wraps around the entire book. But it is only when the book is opened and the pages are fanned out a little (as in the photograph left) that the full beauty of the work is revealed. Each page of the book has a 3mm stretched fragment of the image which bleeds off the edge, as simple as it is stunning. The attention to detail is impeccable; a section of the image is also printed on the edge of the hardback cover to increase the density of the image.

The only problem this printing effect has is that it tends to disturb the tranquil white space on the opened spreads.

B010:01|02
Design: Warren Denyer Design
Title: Exposé
160 x 160 x 2mm
24 pages
1996
United Kingdom

This small promotional brochure for ISTD Fine Papers has a plain white cover except for a strip of scratch-off foil, which when removed reveals a pun: the title of the booklet is 'Exposé'.

Inside, the pages utilise laser-cutting, a process where intricate images can be cut through the paper with a laser.

B011:01|02|03
Design: North
Title: Jacqueline Rabun
303 x 215 x 7mm
28 pages
ISBN: 0-9531463-0-8
1999
United Kingdom

A beautifully conceptual book for a jewellery designer who works solely in silver and white gold, and always uses the motif of a small hole somewhere on the piece.

The book is case-bound with a printed paper cover in solid silver. No title or any information appears on the cover, the only information being on the spine, where the jewellery designer's name and the ISBN number for the book are printed.

Inside the book the minimal design continues: no images or text appear in the entire book with the exception of the colophon, which is discreetly printed at the back. Each page of the book is printed full-bleed in a different shade of silver. The effect is increased by the use of cast-coated paper, which helps to create a strong contrast between the gloss and matt sides. A small 3mm hole has been drilled through the entire content, as a graphic reference to the motif used on the jewellery designer's work.

B012:01 | B013:01
Design: xheight
Title: Trans >6
254 x 203 x 15mm
220 pages
1999
United States of America

'Trans>' is an arts and media journal produced as an English and Spanish bilingual edition, published in America. The cover has the title printed as a spot matt-UV varnish on a white background, with a thin black rule running across the bottom.

Inside, the majority of pages are printed in black and olive green, with the exception of a small full-colour section halfway through the journal. The quiet and calm of this clean design is interrupted by the work of Jorge Pardo, who has an eight-page fold-out section of work that has gone through a office shredding machine. This is directly followed by a piece by Jac Leirner, who has produced a set of four sheets of randomly hole-punched white paper.

These two pieces of work act like an installation set with the calm sensibilities of an art gallery space. The action of flicking through the journal is disturbed when the work of Jorge Pardo is arrived at, as these wild shreds break free of the book.

jorge pardo

B014:01|02
Also see
B032:01 →
B033:01|02 →

B014:01|02
Design: UNA (Amsterdam)
Title: Voices
320 x 245 x 27mm
168 pages
1998
Holland

'Voices' was produced to accompany an exhibition based on the theme of the voice, showing work by various artists who experiment with the interplay between the human voice and the visual image.

This large-format book showcases work by the various exhibiting artists. A 21mm circular hole is die-cut through the centre of the front cover, and the same-sized hole then recurs on the following pages. It does not align perfectly with the cover, but is offset by 3mm. This pattern is repeated throughout the rest of the introductory section of the book. This series of staggered holes builds up into a passage through the contents, revealing fragments of the following pages.

B015:01|02
Design: Designframe
Photography: François Robert
Title: Seeing: Doubletakes
210 x 210 x 12mm
78 pages
1998
United States of America

Working with an amusing series of images by the photographer François Robert, which reveal human faces found in everyday objects, the designers have carried the idea through to the front cover of the book. This is made of unprinted, plain grey bookbinding board out of which three holes have been die-cut to show a fragment of the title printed on the first page of the content. The holes create yet another face, and the section of the visible title could be likened to teeth.

B016:01|02 | B017:01
Design: North
Title: Panache
175 x 130 x 20mm
256 pages
1998
United Kingdom

Panache is a range of paper produced by McNaughtons. For this sample swatch the designers produced a 256-page book instead of the more ephemeral styles of swatch which tend to feel more disposable.

The contents of the book are broken into a number of different sections, one for each weight of stock. The only printing on these pages is the weight, printed in yellow on just the first sheet of each section. The great majority of the book is left blank, except for a small section towards the back which illustrates various printing techniques such as embossing, spot-UV varnishes, die-cut holes, four-colour reproduction, perforations, fold-out sections etc.

The cover of the book is left blank except for a grid structure of small circular perforations. The edges of the book are printed in yellow, continued around onto the spine, which also contains information about the range, such as weights and sheet sizes.

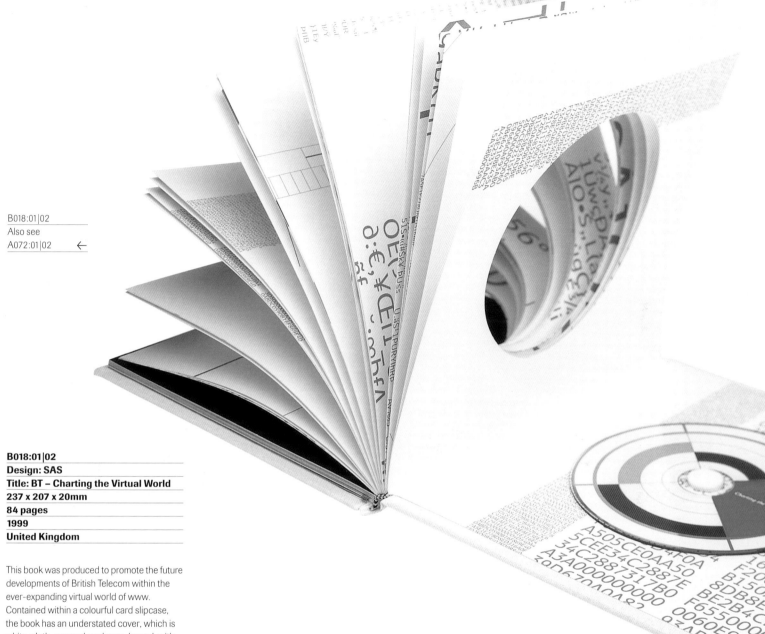

B018:01|02
Also see
A072:01|02 ←

B018:01|02
Design: SAS
Title: BT – Charting the Virtual World
237 x 207 x 20mm
84 pages
1999
United Kingdom

This book was produced to promote the future developments of British Telecom within the ever-expanding virtual world of www. Contained within a colourful card slipcase, the book has an understated cover, which is white, cloth-covered, and case-bound, with the company logo embossed on the front and the title embossed along the spine

The first section of the book contains various abstract illustrations, photography and information about the company's new developments. After this conventional section comes the surprise; the last three-quarters of the book have a die-cut hole punched through all the pages, which reveals a CD held on the inside back cover of the book. These pages feature fragments of information and digital coding.

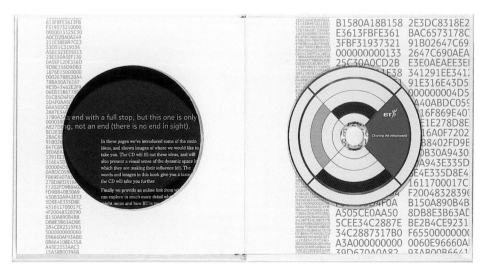

B019:01
Artist: Hans Peter Kuhn
Title: Künstlerhus Bethanien Berlin
240 x 165 x 7mm
16 pages
ISBN: 3-923479-70-0
1992
Germany

This catalogue for the German sound installation artist Hans Peter Kuhn is beautifully restrained. The cover with its plain grey boards has the title discreetly embossed on the front. The cloth-covered spine protrudes out from the cover boards, which adds a tactile contrast. Inside, the design is simple and classical.

On the inside back cover a recessed die-cut circular hole is constructed to hold an audio CD with various sound recordings made by the artist. The CD is printed in solid grey to match the colour of the cover boards, and is without any typographic information. The recessed hole is made to the same thickness as the CD, so when in position the inside back cover is totally flush.

B020:01|02
Also see
B052:01 →

B021:01|02|03
Also see
B052:01 →

D.G. VAN BEUNINGEN
WHAT ACTUALLY HAPPENED
AT THE LAST MEETING OF OUR
SUPERVISORY BOARD WORTH THE
SPUTE IN COMPANY THOUGH WHEN
CAME UP ONCE AGAIN
YOU HAVE TO MAKE SURE THAT
THIS IS ABOUT
OPERATION OF THE COMPANY
IF THERE ARE THREE MANAGERS
AND THEY ALWAYS DISAGREE
THE BUSINESS CANNOT REALLY
FLOURISH UNLESS ONE OF THEM
TAKES THE LEAD

IT WAS THE SAME IN MY DAY
WHEN FRITS VAN VLISSINGEN –
MY BROTHER-IN-LAW, DR FH – WHEN
HE WAS GIVEN A PROMINENT POSITION,
WE IMMEDIATELY CAME INTO CONFLICT.
WE HAD TO REACH AN AGREEMENT.
GEORGE, HE SAID, WE'RE BOTH
'EINSPÄNNER' (HORSES THAT PULL A
CART ON THEIR OWN), WE CAN'T WORK
AS A TEAM – YOU TAKE ROTTERDAM
AND ALL THE FOREIGN OPERATIONS,
AND I'LL DEAL WITH GERMANY, COAL
PURCHASING AND THE NETHERLANDS.
AND THAT'S WHAT WE DID. WE STUCK TO
OUR AGREEMENT UNTIL THE WAR.

THINGS ARE DIFFERENT NOW.

B020:01|02 | B021:01|02|03
Design: Irma Boom
Title: SHV Thinkbook
226 x 170 x 114mm
2136 pages
1996
Holland

This book is so complex and intricate in its production that it took the designer over five years to complete. From the outside the book has a fairly conventional format, other than the weight, 3.5kg, and the thickness, 114mm. However, the book features images and text printed on the edge of the page, only visible once the book is opened up. Other hidden elements include a message printed only as a watermark on specially commissioned paper and the dates of the company's centenary printed inside the spine. The book utilises many unusual techniques, including pages with text laser-cut through the paper.

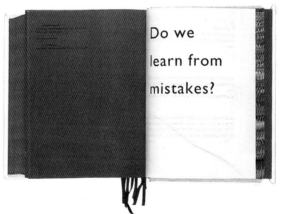

06_Folding

09
eleven minutes walk

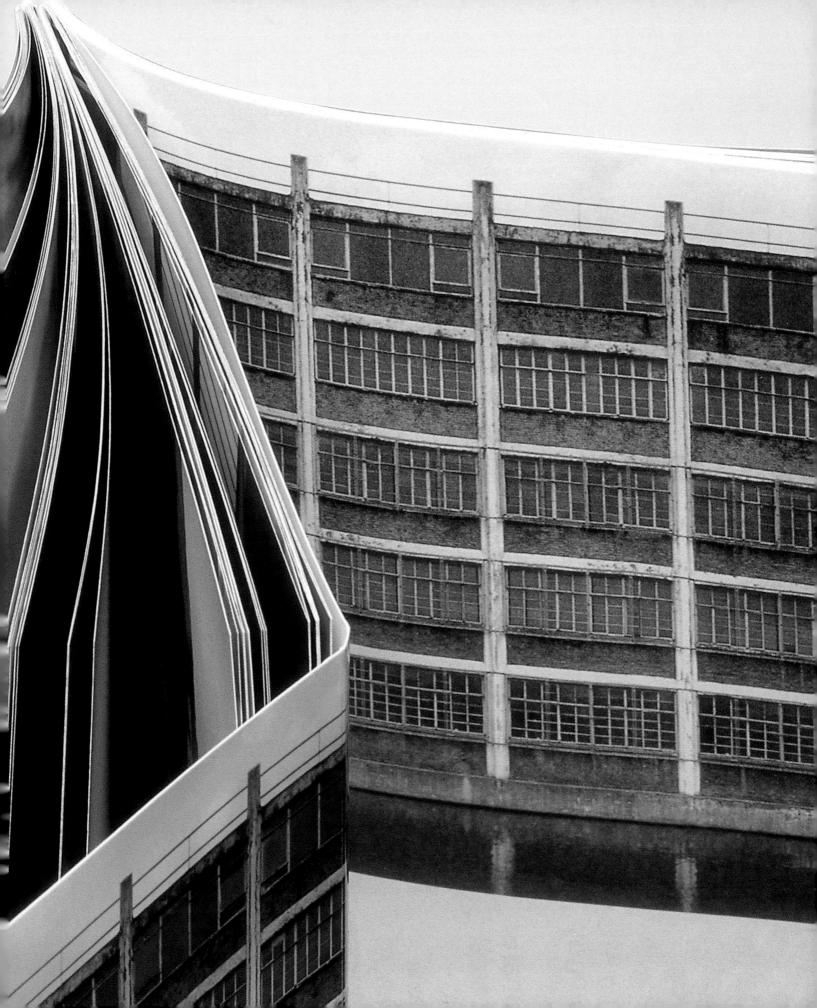

**Introduction
by John O'Reilly**

"I write: I inhabit my sheet of paper, I invest it. I travel across it."
Georges Perec: 'The Page in Species of Spaces and
Other Places'

Georges Perec's essay on 'the page' draws our attention to our naturalised relationship to the page. He writes about our vectors of reading the text on page, say from top to bottom, so the words 'top to bottom' run vertically down the page. The sentence "I start a new paragraph" starts a new paragraph. You get the picture. It's a self-reflexive essay on the topography of the page, on the spatiality of the book. In an essay on Space he recalls the childhood joke of writing your name and address on your copybook concluding with something like "London, England, Europe, The World, The Universe". And he offers some advice to readers: "Start to get used to living in a state of weightlessness; forget verticals and horizontals: Escher's engravings, the inside of spaceships in '2001: A Space Odyssey'."

Like the spaceship in '2001' the books in this section detach readers from the sense of gravity which conventional pagination provides. And like Escher's engravings our sense of space, of what's inside and outside, is skewed. To handle and open Roundel's design of the Pure brochure for Zanders FinePapers is to enter a labyrinth. You turn the folds from left to right as you would a conventional book. Then you open it again from the bottom and a barely viewable message extolling the virtues of the paper appears on what is now effectively a poster. Like a labyrinth, the self-satisfaction in discovering a whole new inside immediately gives way to the realisation that you can't get back to the original. It's a genuinely odd feeling of being unmoored, of being lost in space. But the designers have ensured for those of use who weren't in the Boy Scouts or Girl Guides, and haven't a merit badge in 'compass skills', that the folds eventually come together.

So why this unease with such a basic shift in format and pagination? McLuhan argues that the traditional book takes its perceptual cues from Renaissance paintings. Unlike the visual cubist mosaic of newspapers with its displays of different size and shapes of photos, columns and font sizes, the book generates a single perspective. In a physical and material sense it creates a 'point-of-view'. It's unsurprising that books which play with this perspective create a slight sense of unbalance.

Other designs stick more closely to conventional book space. HGV's 'See' brochure for another paper company has an extended concertina page. It has a kind of visual humour when you open it out to reveal an arm with the word 'touch' on the hand.

All of these books and brochures make demands on the user. By unpacking the two-dimensional space of the conventional book they present a different route, a different map through 'the book'. The user experience of the Pure brochure, Cartlidge Levene's Typographic 51 and UNA's diary Tweeduizend-1 is uncanny. Like Georges Perec, they present the reader with a conception of space itself. Through the folds of the page the inside becomes the outside and the outside becomes the inside. What's the form and what's the content? It's not just the space of the page they have disturbed, but they momentarily disorient the user by rebuilding the architecture of the book. What so strange is that the result is an architecture without depth.

The momentary effect of disorientation, of vertigo, of weightlessness you experience with these books is similar to an effect described by Frederic Jameson in 'Postmodernism or The Cultural Logic of Late Capitalism'. He writes, "This latest mutation in space – postmodern hyperspace – has finally succeeded in transcending the capacities of the individual body to locate itself, to organise its immediate surroundings perceptually and cognitively to map its position in a mappable external world."

Though Jameson is talking about architecture, and specifically the Bonaventure Hotel in Los Angeles, a similar phenomenon is at work in the format of these books which fold space. Jameson's general theory is that our age has a weakened sense of time and history, and a greater sense of space. This is partly to do with technology. McLuhan's conception of the Global Village is one example. There are also cultural and economic reasons which are summed up by the term globalisation. History reappears but transformed from a genuine map of the past into theme parks, themed restaurants, fashion. Jameson argues that our inability to connect meaningfully with the past makes it difficult for us to provide existential 'maps' of our present and future.

UNA's all-in-one diary for the years 1999 and 2000 would appear to be a perfect example of space colonising time. Even the title points to the relativisation of time. At the top of the cover page there's no date as such. Instead of time you are given a mathematical equation, "two thousand – 1". The diary concealed with that for the following year, is called "ninety-nine + 1". And the brief introduction seems to confirm this relativisation of time. Time is marked by "the ebb and flow of ocean tides pushed and pulled by an orbiting moon, circular seasons and perennial holidays, the birth of a child, the death of a loved one. The irony is, despite time's trumped-up importance (it counts for something but doesn't actually mean anything), we need to know neither the time of day nor day of the week nor month of the year to live."

B024:01
Also see
B037:01|02 →

B024:02
Also see
B031:01 →

B024:03
Also see
B034:01-05 →
B035:01|02|03 →

B025:01
Also see
B032:01 →
B033:01|02 →

The book was created in the offices of UNA in Amsterdam and London. As Nick Bell, the London designer, explains, "In the Amsterdam office they came up with the concept of folding, for it to be a two-year diary. They wanted to do something special for this particular year. But at the same time they wanted to play down the Millennium aspect. By doing a two-year diary, with it all contained in one rather than two separate diaries, the changeover from one year to the next is less obvious. The idea they wanted was time carrying on regardless of the event, and how our idea of time is an artificial thing." Even though the people involved in creating the format had a lot of experience, the only way to figure out the mechanics of it, according to Bell, was to sit there with a piece of paper and try it out.

Weeks are measured out by phrases at the top of each page like 'thunder racks' and 'a puddle forms'. In light grey type the numbers 8 to 20 run vertically down the page, but unlike most diaries there are no lines on the page to give a strict demarcation between days, or morning and afternoon. There is an expanse of white space. As you finish each week you unfold a page. As well as beginning to mark out the following year's dates, it also reveals an image chosen by Bell with a view in part to emphasising the artificiality of the book's chronology itself. "They had a writer write a continuous line of events happening regardless of anything. Whatever happens, these things carry on. It was always going to be down to chance as to what words sat next to what images. So there are some quite nice juxtapositions happening." Some text integrates with the image, other text floats on the surface, drifting in limbo like the secret knowledge of the insane. An image of a country road disappears into a misty vanishing point underneath the thought "bats hang from the eaves".

Bell continues, "All I was doing was getting hold of the images. I had spoken to Anthony Oliver and realised he had a enormous archive of past work, so we didn't commission any new images. It was pretty much what we already had. It would have been too expensive to commission. I went through his images and what I was doing was trying to show how our sense of time comes from the landscape, or the weather, or the cycles of seasons. How a knowledge of climate helped to forecast when to plant seeds. I was reading James Frazer's 'The Golden Bough' to get an idea of all these cults and rituals. It described the origins of all these superstitions and the importance of being able to forecast weather, and the importance of fertility in general because survival depends on it. I got from that how the calendar and certain anniversaries came from the land. I tried to sequence the images roughly according to the weather of the seasons. A lot of the images are quite dark in winter and when you go through the summer months, they are much brighter. A lot of the images early on refer to the basic elements: fire, water, the soil, the air."

The photo images at the beginning of the diary are perfectly set on the page. But as you go through they begin to fall off the edge: others appear. Like the occasional asynchronicity between text and image, Bell used the photos out of synch with the page as a visual metaphor for how our own way of organising time falls out of synch with the original pagan celebrations that still dot our calendar. Bell argues that "We are holding anniversaries which are completely inaccurate because of mistakes with calendars and calculations through the centuries. One image slips out of synch and other images start to appear. With a high-res scan we feathered the edge of the photos so there wasn't a sharp division between images, to give the sense of continuity."

It would be easy to see "two thousand–1" and "ninety-nine+1" as postmodern in their rejection of mechanical, uniform time and their resurrection of a more authentic natural time. A kind of new-age diary. But the construction of the diary is more complex than that. There's the time on the page where you fill in your appointments but the paper is thin enough for the images to show through slightly. The thin quality of the paper allows you to see the time underneath the photo. In a metaphorical way the UNA diary and the Pure brochure function in the same way as the visual enigma of the Moebius strip, which seems to have two sides but only has one.

Ultimately the UNA diary, rather than illustrating the notion of an original pagan time measured in the forces and cycles of nature, suggests the idea of multiple time. Pagan and urban, natural and technological as continuous. In the double cover for the diary, time folds over itself and unfolds out of itself. The diary is the perfect vehicle for exploring the structure and topography of the book. If its experiment with the spatiality is initially unsettling, it's only because we've become habituated to the technology of the conventional book. Ultimately UNA's thinking through the space of the book is a platform for a theory of time. French philosopher Gilles Deleuze wrote an entire book on the concept of the 'fold' in the work of Leibniz and in the Baroque. Deleuze conceived the fold not so much as a question of space but an issue of time. "To think is to fold, to double the outside with a coextensive inside… every inside-space is topologically in contact with the outside-space… And this carnal or vital topology, far from showing up in space, frees a sense of time that fits the past into the inside, brings about the future in the outside, and brings the two into confrontation at the limit of the living present."

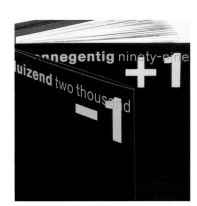

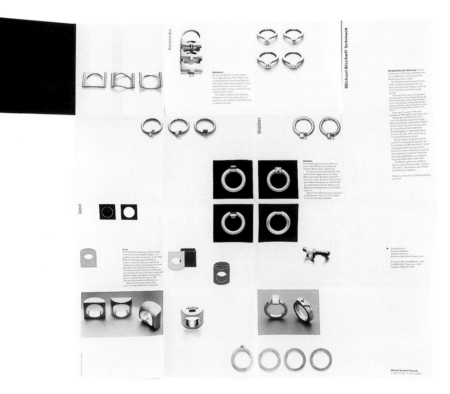

B026:01
Design: hdr design
Title: Michael Bischoff Schmuck
100 x 100 x 3mm
16 pages
1998
United Kingdom

Produced for the German jewellery designer, this brochure has a very understated cover; no information is disclosed from the outside, just a plain black card with a black elastic band used to seal the brochure. Even after opening the cover no information is disclosed. It is not until the brochure is unfolded that the designer's name and details are revealed. Once unfolded the brochure, measuring 395 x 395mm, is neatly folded down to the final pocketbook format.

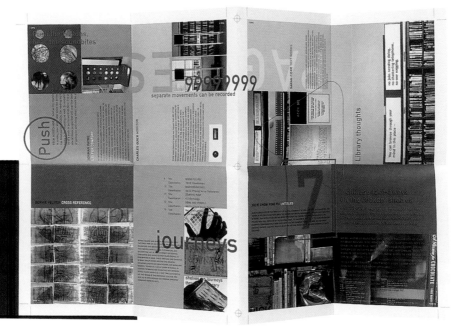

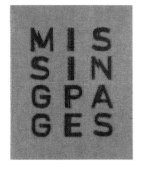

B027:01|02|03
Design: The Thompson Design Office
Title: Missing Pages
200 x 163 x 6mm
16 pages
1999
United Kingdom

'Missing Pages' is produced to promote an exhibition held in various libraries across Lancashire. This book-cum-brochure-cum poster looks from the outside like a conventional case-bound book. However, as soon as the cover is opened the difference is revealed, and the content unfolds to a large poster or broadside. The book makes various references to libraries, such as the date-stamped sheet tipped onto the inside front cover.

B029:01
Also see
B026:01 ←
B038:01 →

B028:01|02
Design: Paul Farrington
Artist: Jorn Ebner
Title: Handbook for
a Mobile Settlement
148 x 105 x 5mm
40 pages
1999
United Kingdom

This artist's book becomes a user manual for building a temporary construction in the wilderness. The book is formed by five sheets of A4 paper printed both sides then folded down to A6. These sheets are then bound with a white elastic band. The result is a book which has 'hidden' pages inside the folds, but unlike a French-folded brochure, the content is easier to access. Also, because the book is bound just with an elastic band, which can be removed, the whole book can be unfolded and worked up into a composition.

O_02

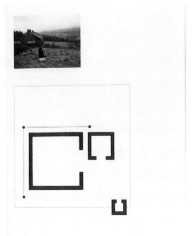

B_03

Saville Jones work with the latest Computer-Aided Design (CAD) system, which enables us to produce working drawings with greater speed, accuracy and flexibility. This also offers an accurate exchange and co-ordination of information and ideas between ourselves and other consultants.

We work by analysing each stage of the design and building process, working with the site, brief and budget to the best practical advantage, enabling the Design Team to reach the optimum solution at an early stage.

By adopting this holistic approach to the built environment a sustainable architecture can be achieved which is exciting and innovative. Without squandering resources, a structure can be created to meet the immediate needs of the client and ably respond to changing conditions during its life-span. These are attributes and techniques we will continue to develop and champion.

Um die Herstellung von Arbeitszeichnungen schneller, präziser und flexibler auszuarbeiten benutzen Saville Jones moderne Technologien und das neueste CAD-System. Dies ermöglicht eine akurate Projektkoordination und einen effizienten Austausch von Informationen zwischen unserem Büro und anderen beteiligten Firmen.

Wir analysieren jeden Abschnitt eines Projektes, von der ursprünglichen Konzeption über die Gestaltung, Ausarbeitung des Budgets bis hin zur Baufertigstellung. Dadurch kann unser Design Team ein optimales Ergebnis erreichen. Durch die ideen gemeinten Schritte wird eine effektive Ausnutzung der gegebenen Mittel erreicht und kurz-, mittel-, als auch langfristige Flexibilität für das Gehäuse mit eingeplant. Die Anwendung dieses holistischen Vorgehens ist Grundlage und Ziel unseres Arbeitens.

Nous avons le dernier système informatique CAD qui nous donne les moyens de créer des plans plus rapidement avec plus de précision et de flexibilité. Ce système permet aussi un échange et une coordination précis d'informations et d'idées entre notre bureau et ceux d'autres experts-conseil.

Nous analysons chaque stade de l'opération de la conception à la construction, en travaillant sur l'emplacement, les directives et le budget le plus avantageusement possible, ce qui permet à l'équipe de dessinateurs de trouver dès le départ, une solution optimum. En adaptant cette façon holistique de considérer la zone de construction, on peut arriver à une architecture qui a un souci, à la fois passionnante et innovatrice. Dans un souci d'économie des ressources, l'édifice ainsi créé répond habilement d'une part aux besoins du client, et d'autre part aux conditions changeantes au cours de la durée de vie. Ce sont des attributs et des techniques que nous continuerons à développer et à défendre.

1 A glass wall to provide a permanent advertisement for the activities within. Magnet Leisure Centre, Maidenhead

2 External building fabric, enriched by the use of light. Magnet Leisure Centre

3 Restoration, derelict barn converted to community theatre. Field Place, Worthing

4 Careful choice of materials and detailing used to effect on a listed building. Field Place

B029:01
Design: hdr design
Title: Saville Jones Architects
310 x 110 x 2mm
14 pages
1999
United Kingdom

This brochure is constructed from just two sheets of paper: one is the green cover stock, the second is a sheet of text stock. However, the brochure still manages to feel substantial even with these minimal contents, as the content is folded into an eight-page section which is saddle-stitched to the cover, then folded back in on itself.

This folded method seems to add more depth to the brochure than if it were a conventional eight-page saddle-stitched product.

The cover is also noteworthy for its washer-and-thread fastening method. The jacket is trimmed to a slightly larger format than the cover, which gives the content a frame when opened.

B030:01|02
Design: Cartlidge Levene
Title: Designing Effective
Annual Reports
258 x 179 x 6mm
44 pages
1994
United Kingdom

This self-promotional brochure for the London-based design consultancy Cartlidge Levene is concertina-folded and can be viewed as a conventional book or extended out to a length of over 3.8m. As printing sheets are not available in this size, the book is in fact constructed from a series of long sheets glued end to end.

The cover is made from a separate sheet which has the concertina-folded section glued onto the inside back cover. It is printed in silver full-bleed with an extended title embossed across the back and front with a diagonal keyline rule printed in orange.

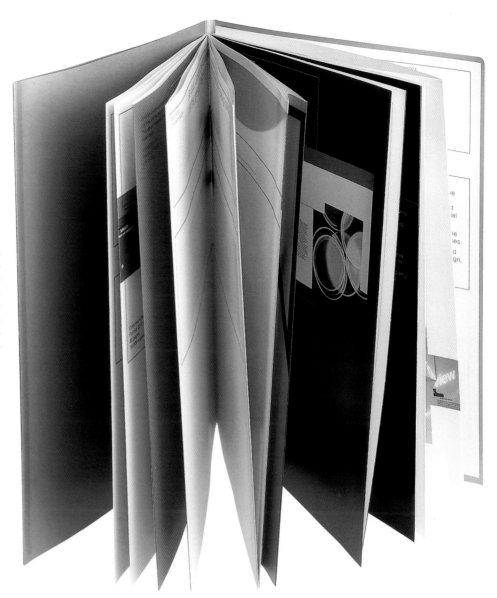

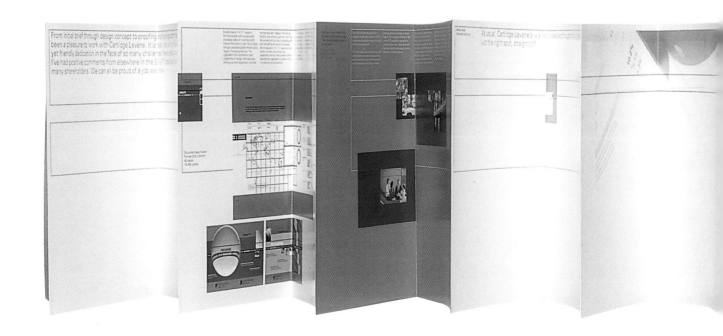

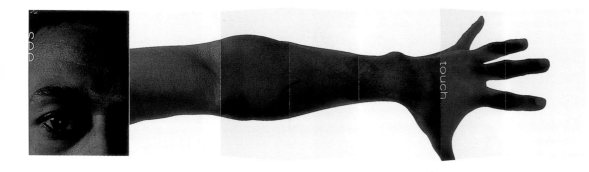

B031:01
Design: HGV
Title: See
148 x 105 x 9mm
78 pages
1998
United Kingdom

A small A6 format is used for this promotional paper sampler from McNaughtons. The book, which is used as a showcase for the paper expounding the virtues of the printing quality obtainable from the stock, uses the human body as its source for imagery.

The model, Adam (complete with fig leaf), is reproduced at life size in the book. This creates some dramatic spreads with just a large fragment of shoulder etc. Although the book is conventionally bound (sewn-section), one spread showing Adam's arm turns out to be a very long concertina-folded section which extends all the way to his fingertips.

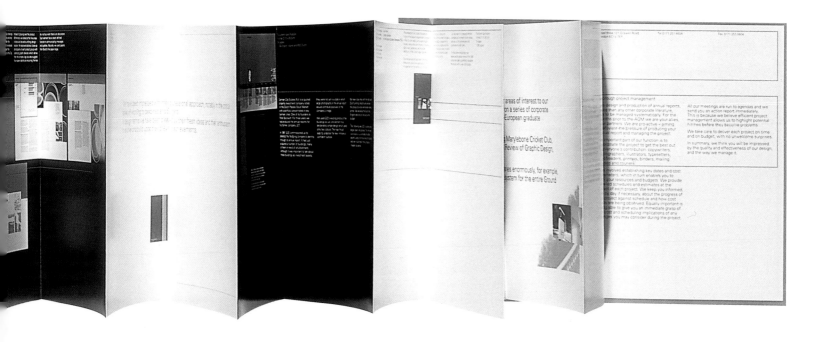

B032:01
Also see
B014:01|02 ←

B033:01|02
Also see
B014:01|02 ←

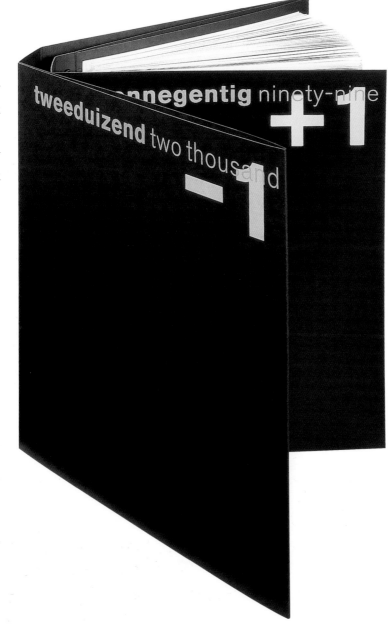

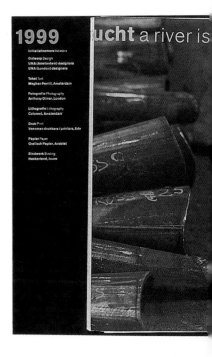

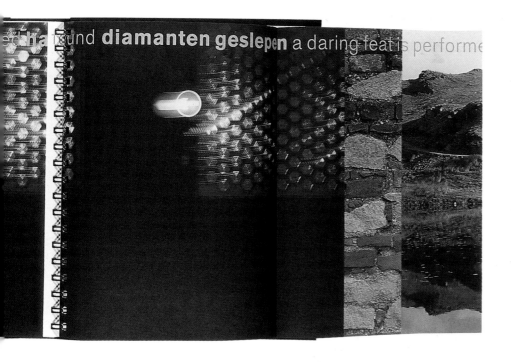

B032:01 | B033:01|02
Design: UNA (Amsterdam)
UNA (London)
Title: Tweeduizend -1
255 x 224 x 30mm
350 pages
1998
United Kingdom/Holland

The Dutch- and now English-based design consultancy UNA is renowned for the design of its diaries. For 1999 it produced a two-year version (1999 and 2000) with a complex series of folded pages.

For 1999, or as the cover describes it, "two thousand – 1", the diary works conventionally from page to page. However, with the dawn of the new Millennium, the outer dust jacket is removed to reveal the new title "nineteen hundred and ninety nine +1". Then, following the detailed instructions on the introductory page, each of the pages is folded back on itself to reveal more of the photography and at the same time conceal the details from the previous year.

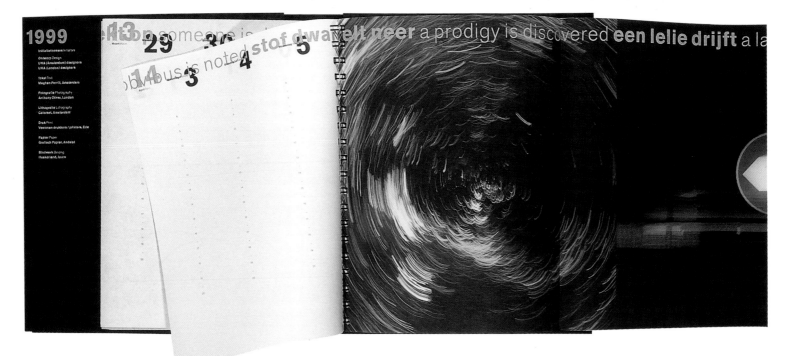

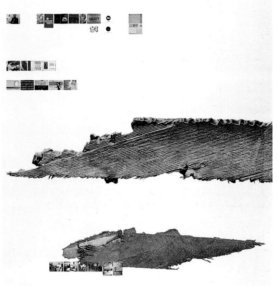

B034:01-05 | B035:01|02|03
Design: Cartlidge Levene
Title: TypoGraphic 51
295 x 212 x 2mm
32 pages
ISBN: 0143 7623
1998
United Kingdom

TypoGraphic is a journal published by the STD (Society of Typographic Designers). Each issue is designed by a different guest design company. This issue by London-based Cartlidge Levene was conceived as a set of two double-sided A1 posters. The posters were designed with the text correctly imposed for when the posters are cut down and turned into a journal.

Once the journal is cut, folded and trimmed, the editorial content works correctly from page to page, and the large abstract details of shredded lorry tyres appear in the layouts at seemingly random positions.

The cover also has a couple of interesting features; first, it is formed as an eight-page section, with the coverlines running vertically up the page, starting on the front and continuing around onto the inside section. Second, a creased recess is incorporated which runs horizontally across the whole cover. This recess contains information about the design of the issue and details about how to obtain copies of the flat poster versions of the issue.

B036:01|02
Design: Herman Lelie
Artist: Christopher Wool
Title: Ophiuchus Collection
224 x 163 x 10mm
28 pages
1998
United Kingdom

Designed for the artist Christopher Wool,
this exhibition catalogue is produced as a
concertina-folded book without a bound
spine, which allows the book to be stretched
out into a long strip.

The covers are made from plain silver-paper-
covered boards with no title or other
information present. This makes the book
hard to orientate, as it is impossible to tell
the front from the back or the top from the
bottom. Only once the cover is opened is it
apparent where the book starts and finishes.

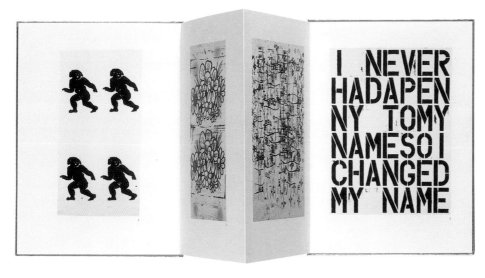

B036:03 | B037:01|02
Design: Roundel
Title: Pure
210 x 148 x 2mm
16 pages
1997
United Kingdom

This leaflet for Zanders FinePapers showcases the Ikon range, a set of four identical brochures, each produced on a different version of the stock.

The leaflet, which is A5 in format, works initially as a conventional document with eight double-section pages. However, it is possible to unfold the brochure into a flat sheet. Once unfolded, the method that makes the leaflet possible is revealed, and the flat sheet is cut along the central fold, which allows the folding to be made.

The leaflet also benefits from a number of specialist printing techniques, such as, embossing, die-cuts, foil-blocking, spot-UV varnishes etc.

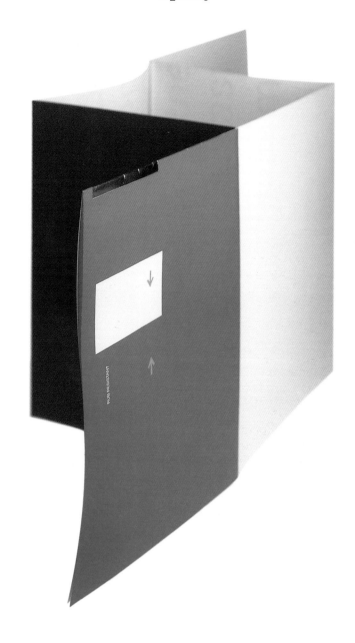

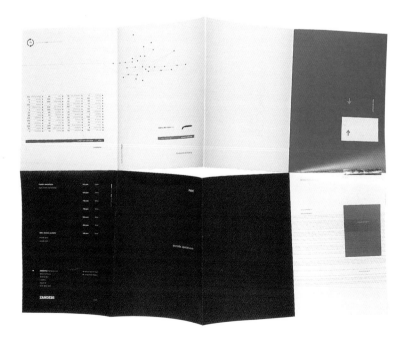

B038:01|02
Design: hdr design
Title: Baseline Invite
150 x 150 x 1mm
6 pages
1995
United Kingdom

This invitation for an open studios event at
a design magazine publishing house needed
to be designed in such a way that it could be
folded to present three different versions, to
enable its use by all three hosts of the event.
Each company could then fold the invite to
present their address details at the top
thereby making them instantly recognisable
to their guests. The invite was posted
folded up and a bellyband was used
to seal the document.

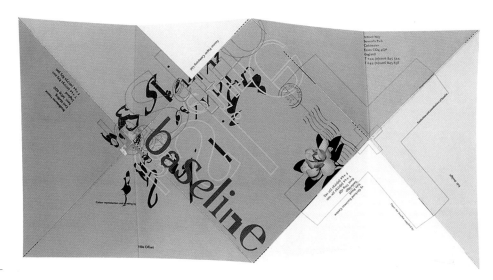

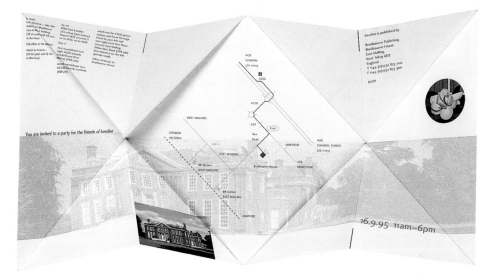

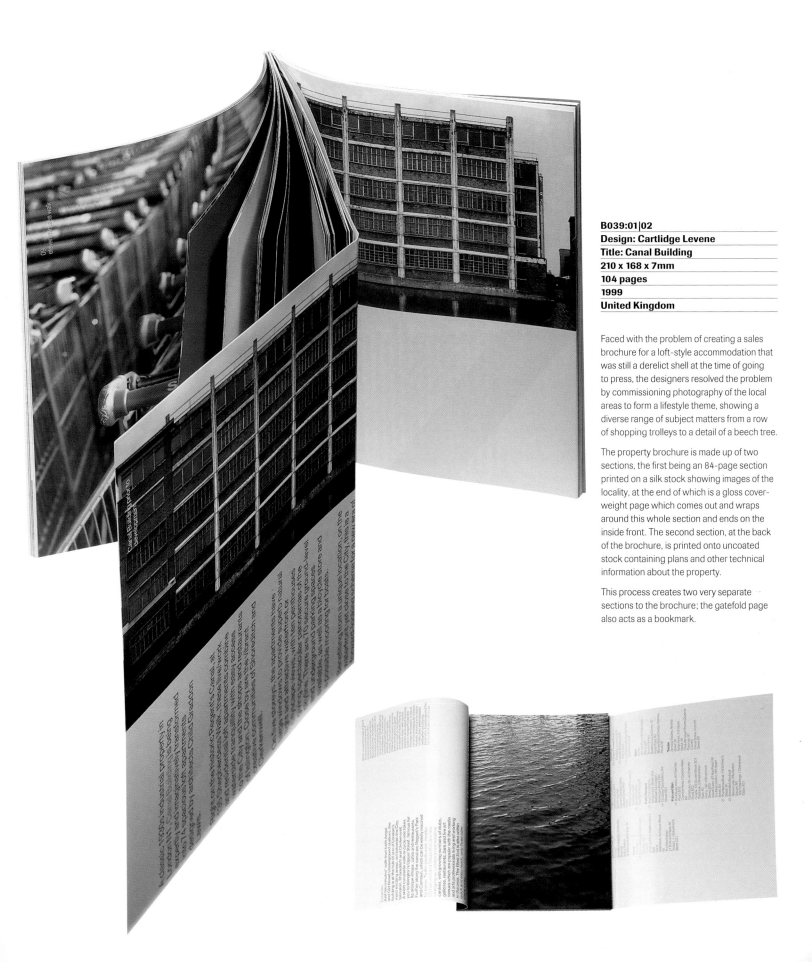

B039:01|02
Design: Cartlidge Levene
Title: Canal Building
210 x 168 x 7mm
104 pages
1999
United Kingdom

Faced with the problem of creating a sales brochure for a loft-style accommodation that was still a derelict shell at the time of going to press, the designers resolved the problem by commissioning photography of the local areas to form a lifestyle theme, showing a diverse range of subject matters from a row of shopping trolleys to a detail of a beech tree.

The property brochure is made up of two sections, the first being an 84-page section printed on a silk stock showing images of the locality, at the end of which is a gloss cover-weight page which comes out and wraps around this whole section and ends on the inside front. The second section, at the back of the brochure, is printed onto uncoated stock containing plans and other technical information about the property.

This process creates two very separate sections to the brochure; the gatefold page also acts as a bookmark.

07_Binding

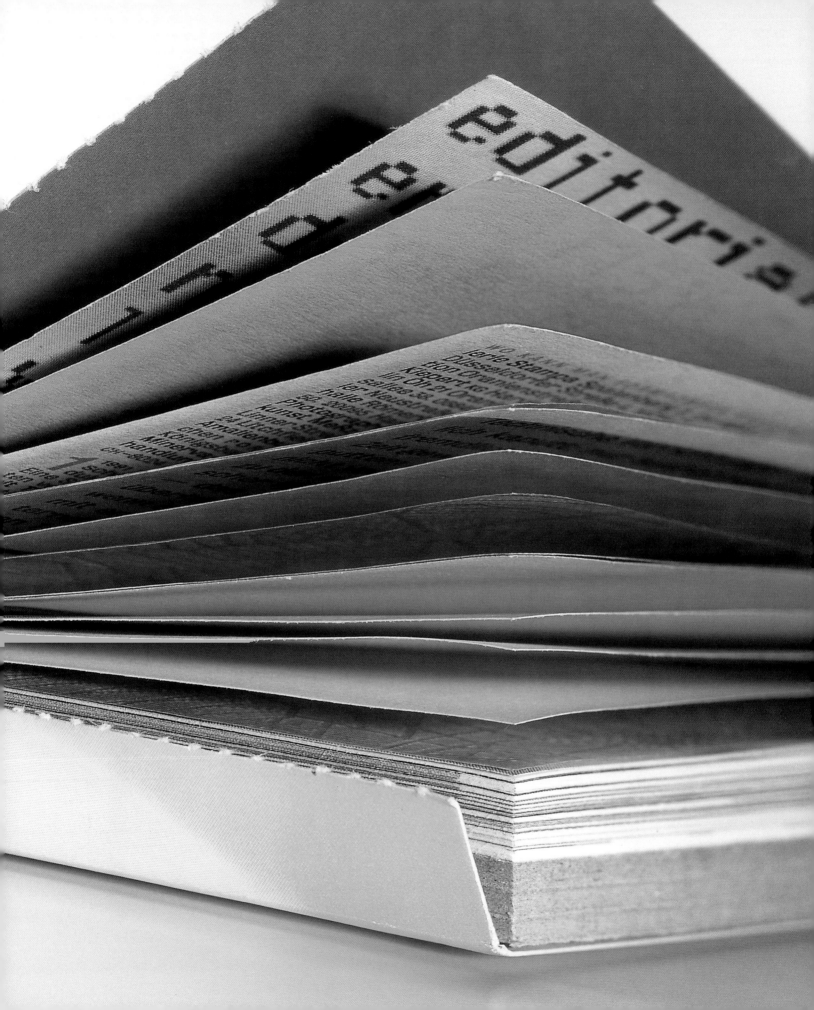

Introduction
by John O'Reilly

When you think of revolutions in book technology, it's always the printing press that comes to mind. But the book really came into being around 1 AD, when the first codex appeared. The codex was an object consisting of leaves of material such as parchment, which were tied together. Up until then readers were faced with the unwieldy unravelling of the scroll. As Bones from 'Star Trek' might have said "It's a book, Jim, but not as we know it." If the codex was a system for storing written information, it would also change the nature of other information storage systems such as the library. The codex was neat.

Over the centuries binding on books has become the uniform system of organising materials. The binding of books presented has another function in that it offers a handy means of display. Conventional binding, with the book's name and author down the side, is also the means whereby the book advertises itself. In an earlier chapter on Formats, the Dome book was an example of a book conceived as a circular shape but whose straight-edge was a nod to concerns about it fitting on a shelf. However, design bookshops arrived at their own answer by piling the Dome book one on top of another.

One book which nearly had its binding removed for commercial concerns was Graphic Thought Facility's 'Stealing Beauty'. Created as a catalogue for an exhibition at London's Institute of Contemporary Art, the designers were told that the white comb-binding would have to go. No-one would buy a book with such anonymous and unhelpful binding. In the end, the designers, as they sometimes do, got their way. The book sold out.

This section offers many examples of creative binding, where the binding itself materialises a concept. Like the wire coat hanger which effectively binds Anni Kuan Design's fashion catalogue, whose clothes are inspired by a trash aesthetic. Or Irma Boom's sewn-together catalogue for an art exhibition called 'The Spine'. The fragile thematic connections between the disparate artists on display was matched by the fragility of the catalogue's spine itself as the overhanging thread begs to be unravelled.

But it's the simple functionalism of Graphic Thought Facility's 'Stealing Beauty' that is the most striking example of binding, inviting fundamental questions about the conventions of the book and our expectations of it. It's also about design itself and its relation to art and life. And this fundamental chain of ideas is driven by the simple, white comb-binding.

The concept of the exhibition 'Stealing Beauty' was partly about designers employing a make-do aesthetic, using everyday objects or discarded materials and turning them into something else. The concept is played out on the cover of the catalogue itself. As Paul Neale of Graphic Thought Facility explains, "A cover is always difficult for group shows. You don't

necessarily want to do a list of names. You certainly don't want to choose one piece of work so that symbolises the whole show. The cover needed another design metaphor. We got these bits from the dummies that we made. Originally we started thinking maybe we can work it into an index by resorting them out. But it was just getting a little bit too anal by that point. It is certainly representative of the bits and pieces inside."

The theme of 'Stealing Beauty', that of ripping out ordinary objects from their original context and transforming them into something new, has a long history – most obviously in Situationist theories, but also in the work of philosophers such as Michel de Certeau, who in 'The Practice of Everyday Life' describes the practice of 'la perruque' or poaching. It's partly a response to an all-pervasive consumer culture. But the objection of de Certeau is not directed at the sheer volume of consumer objects but at the way these products presume a specific kind of use. They impose on us a kind of silent, invisible discipline. They create a kind of existential grid which organises our perception and experience of the world. 'Stealing Beauty' at some level was a response to this discipline of consumerism, showing work by designers like Michael Marriot, who takes a bucket with its association of domestic chores, and turns it into a light vessel by recreating it as a lampshade.

According to Paul Neale, the decision about the binding was prompted by this practice of transformation. "Quite obviously it struck us that all of the designers were partly working with readymades. Or that their design process, with a few exceptions, involved using low-grade materials doing the absolute least to transmute the object into something else. Adding a concept to these low-grade materials generated a lot of richness. Obviously Mr Marriot's light is an example. An absolute minimum was done with it. We sort of aligned that with comb-binding. There are a lot of things that are in that squeamish 'officey' area, that with a bit of a nudge have got that sort of 'don't care' association. But the challenge of making the binding feel beautiful through appropriateness was something that interested us."

The point is that the binding wasn't an example of bad taste, or shockingly ugly. In effect, what Graphic Thought Facility did was swap the discipline, the rules of use for a functional office object, for their own discipline, for the set of design rules they generated for themselves from the project. As Neale reflects, "What interested us was the flexibility that the plastic comb-binding can bring. It brings us flexibility in a limited budget printing a minimum of full colour. It enabled us to spread that full colour out exactly where we wanted in the publication. The other use we saw in the comb-binding was that we knew as a catalogue, a majority of the imagery we would be getting from the individual designers would be

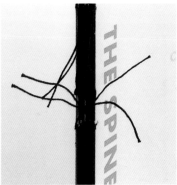

mixed quality. Because it would come from a variety of sources it would essentially have a randomness to it. Although we shot about a third of the images ourselves, we saw the comb-binding as a way of physically tying together all these random elements. The use of the various stocks and the various sizes is a way of going with that randomness. But the grid is what's really holding it together. Which is that every single image, full-bleed or whatever, is attacked by the comb-binding; everything works to the inside bottom of the page."

In a sense the whole 'make-do' approach is at the heart of the work by Graphic Thought Facility. The book is the size that it is because it's economic. The printer they use has one B3 and one B2 press, and the size they chose meant that they could get four sheets on to view. The inside cover has an embossed champagne label with metallic printing attached to the bottom right-hand corner, which they got free from the sponsors. While adding to the pick-and-mix effect, it also adds texture. They used wood-free paper because it was cheap. Even the printer's credits at the back of the book was a photo whose content was created out of found objects. "Rather than give the printers the usual credit, we thought it would be nice to shoot a still life. Going down there beforehand we'd seen the way they made out of all the print waste these little ink cartons, these 'bishops hats'. It's an old Fleet Street thing. We'd seen them doing this with our jobs before. We asked them to make them up out of some of the pages from the inside."

The 'Stealing Beauty' exhibition was in part a response to our slick design culture. Design is no longer simply a professional expertise bought by clients but the very thing that binds together our contemporary culture of 'lifestyle', from Sunday supplements to TV programmes on interior design, garden design and even the cookery programmes which promote nothing other than food as a lifestyle choice rather than body fuel. As some commentators have pointed out, the phenomenon of 'Cool Britannia' was an exercise in styling and designing identity. But slick design can't bind a national identity or a collective sense of unity.

And it's the binding of the book that above all else makes it whole. Of all the components that go into constructing a book, it's the binding that is most fundamental in our conception of it. There are many examples in this chapter on binding, from M&Co's 'Strange Attractors: Signs of Chaos', to cyan's 'Form+Zweck 11/12' that hold the book together while simultaneously exposing the conventions of its construction. And this is also at stake in 'Stealing Beauty'. The binding doesn't hide or stand aside for what's inside. In the words of Paul Neale, it 'attacks' the page.

One of the attractions of working on books, for Neale, is the opportunity to create something that challenges our assumptions about books. "I like books for what they allow. They let you take an idea because you are presenting a set of components, i.e. spreads. And you've delivered an idea through the impact of the book, its format and the cover. You can develop it quite a long way. That's the great thing about the book format: you can get people to understand things, then you can start playing with preconceptions. It's the nearest format in printed graphics to a time-based medium. Something we are very much aware of is tactility. It doesn't apply just to books, it applies to everything: poster design, packaging, exhibition design. Being attentive to tactility and surface materials, working with process, is something that book design lends itself to, because by its nature a book is relatively complex in its construction. Also because there are so many books, people have in-built preconceptions."

'Stealing Beauty' itself raises some fascinating questions about some major preconceptions – most significantly the relationship of design to art. Implicit in the name of the exhibition is not just the theme of creating the extraordinary out of the ordinary, but also perhaps the idea of designers stealing beauty from the domain of art. The essay in the catalogue alludes to this issue. But the very fact the exhibition was held at the Institute of Contemporary Arts in London is a kind of validation in itself of design by an institution which obviously confers the status of art on the exhibitions it shows. If it's in a gallery, it's art – although there is some irony in the fact that the idea of the beautiful has long disappeared from the vocabulary of contemporary art.

But what about the catalogue 'Stealing Beauty'? What about the relationship between graphic design and art? Some graphic designers still agonise over the commercial constraints on their work, often justifying some jobs because it allows them to do their own more 'creative' work. This is despite the fact that arguably the greatest artist of the late 20th century was a commercial artist, and Andy Warhol would have sold his soul to the devil if it could have been screenprinted and made by an assistant.

Ultimately the aspiration of graphic design to be art is a misplaced one. Though they are not working to a brief, artists require buyers and contemporary artists are promoted with as much zeal as an agency selling crispy fried chicken. The very disposability of much graphic design gives it a speed and a purchase on the pulse of the culture that artists can only imagine. At its best it is graphic thinking that exploits and surfs the commercial constraints that seem to impose severe conditions. The white comb-binding of 'Stealing Beauty' may have originated from the 'squeamish' symbolic universe of the office stationery cupboard, and resolved the practical requirements of a tight budget. But the designers have rethought it and re-conceptualised it as a technology for interrogating the conventions of the book.

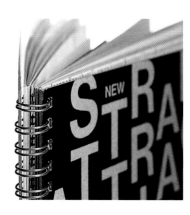

B044:01
Also see
B008:01|02 ←

B045:01|02
Also see
B008:01|02 ←

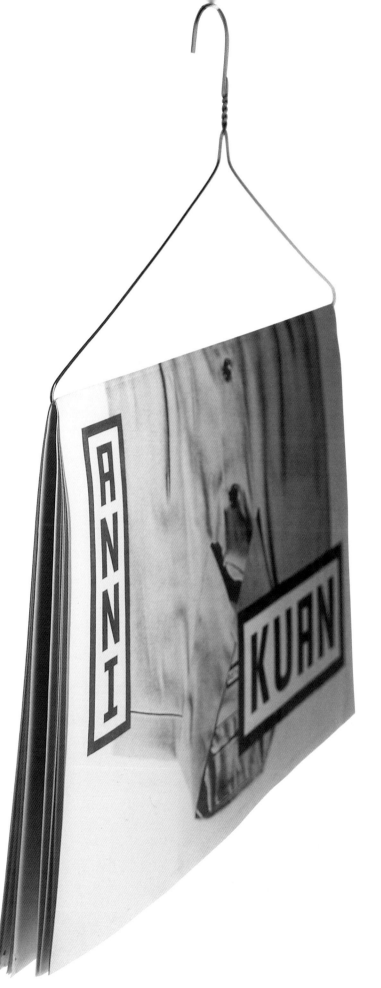

B044:01 | B045:01|02
Design: Sagmeister Inc.
Title: Anni Kuan Design
290 x 395 x 1mm
28 pages
1999
United States of America

Faced with a modest budget and a fashion collection loosely themed around laundrettes, the designer created this unique fashion brochure which is delicate and beautiful, while at the same time cheap and disposable.

The photography, which purely shows just the clothes – no supermodels – includes shots such as an overcoat daubed with the painted message 'quilted coat with fake fur scarf' and a turtleneck sweater being watered on by a pooch. The credits page utilises typography constructed from ripped-up strips of white cloth laid on the studio floor.

The brochure is printed on newsprint by inexpensive local newspaper printers. The brochure is then bound by simply hanging it from a wire coat hanger, again a reference to the laundrette.

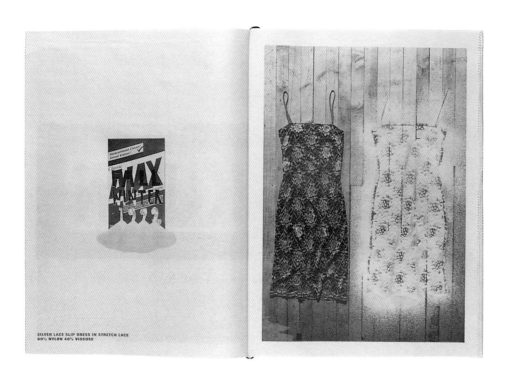

SILVER LACE SLIP DRESS IN STRETCH LACE
60% NYLON 40% VISCOSE

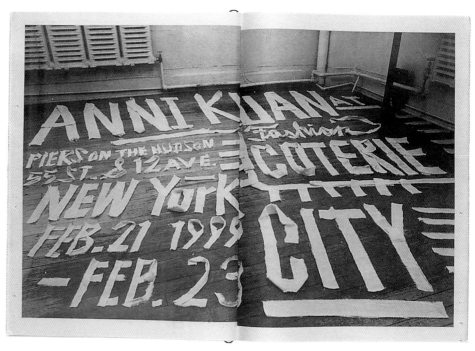

B046:02
Also see
A075:02 ←

B046:01
Design: Zoe Scutts
Title: Untitled
74 x 50 x 7mm
34 pages
2000
United Kingdom

The photographer Nick Veasey works
predominantly with x-ray photography,
a reference which is picked up through the
size and format of this brochure. Reminiscent
of the small x-ray film used by dentists for
checking fillings, the brochure is a set of such
sized cards, with rounded corners. Each
card is matt-laminated to give a more plastic
quality. The cards are simply bound with
a ball-linked chain, again adding to the
medical/industrial quality.

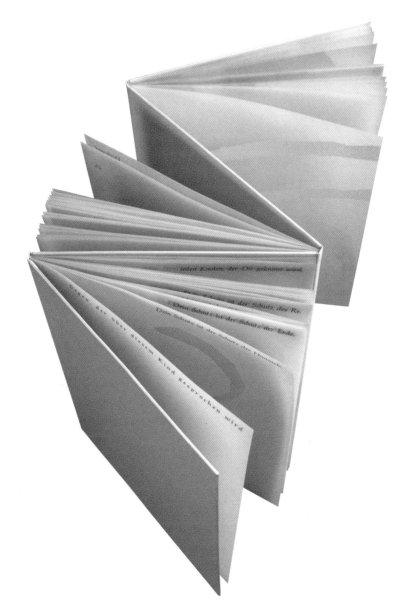

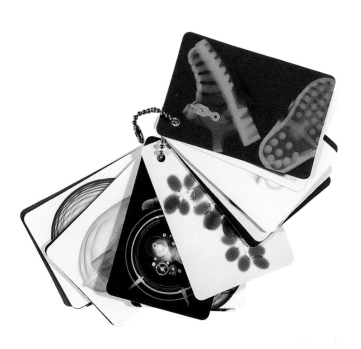

B046:02
Design: Unica T
Title: Zyklus
380 x 215mm
156 pages
1998
Germany

This book, created by the artist book designers
Unica T, manages to build three separate
52-page books into one. This is achieved
through the cover being formed as a zigzag
shape, which allows three separate spines
to be used.

Three ancient poems from Egypt, India and
Japan tell of the cycle of birth, life and death,
and are printed with a combination of
linocutting and letterpress on transparent
paper. The cover is white with the title blind-
embossed on the front. The book was
hand-printed in an edition of 20 copies.

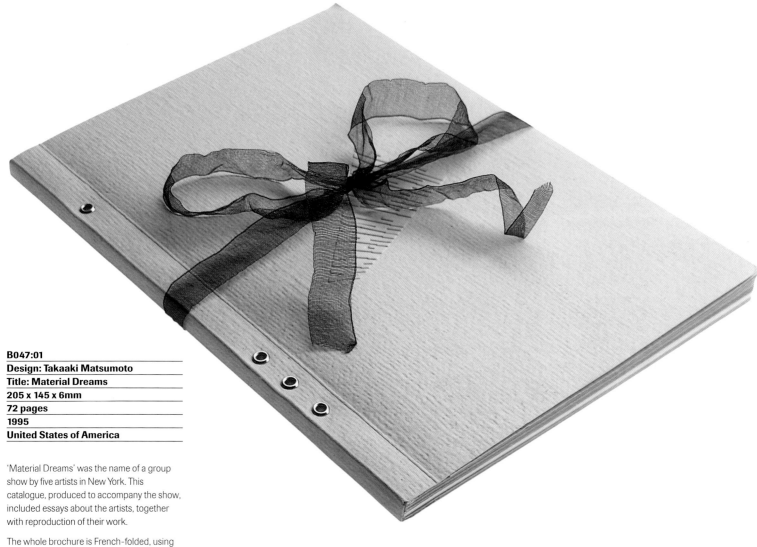

B047:01
Design: Takaaki Matsumoto
Title: Material Dreams
205 x 145 x 6mm
72 pages
1995
United States of America

'Material Dreams' was the name of a group show by five artists in New York. This catalogue, produced to accompany the show, included essays about the artists, together with reproduction of their work.

The whole brochure is French-folded, using various coloured and textured stocks. The cover is made from a heavily textured stock which has the title embossed in the centre. The brochure is bound with a set of small-gauge rivets which are arranged along the length of the spine.

The catalogue is bound still further with a delicate black lace ribbon tied in a bow on the front. The ribbon passes through two slits on the back cover to prevent it from slipping off.

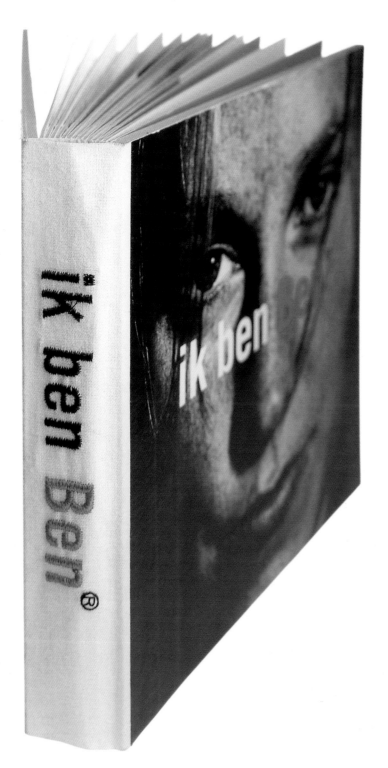

B048:01
Design: KesselsKrammer
Title: ik ben Ben
197 x 179 x 31mm
32 pages
1998
Holland

This corporate user manual was designed for Ben, which is a mobile phone service provider in Holland. The book, although only 32 pages long, has a real substance to it as a result of the pages being bonded to bookbinding board. The covers are 5mm thick, and the back cover contains a recess to hold a floppy disc.

The book has a specially created cloth spine with the title of the book intricately sewn into it, matching the typography used on the cover.

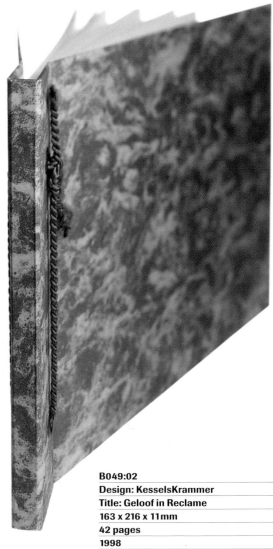

B049:01
Design: M&Co.
Title: Strange Attractors: Signs of Chaos
190 x 228 x 8mm
72 pages
1989
United States of America

A catalogue from an exhibition at the New Museum of Contemporary Art in New York plays with various themes of chaos theory.

The book is wire-bound and initially turned inside out, so the cover (as shown here) is somewhere in the middle of the book. A belly band is used to keep the book 'out of order'. The book also employs a variety of page sizes and stocks to help create more chaos within the pages.

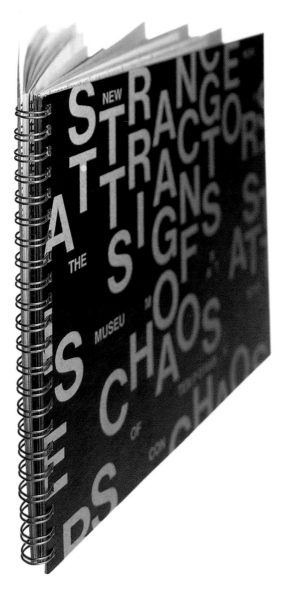

B049:02
Design: KesselsKrammer
Title: Geloof in Reclame
163 x 216 x 11mm
42 pages
1998
Holland

A strong reference to an old photograph album is created in this promotional brochure for the Dutch newspaper 'Het Parool'. The pages include reproductions of newspaper cuttings yellowed and faded, stuck together with sticky tape.

The cover is printed with an old marbling effect and the title is set in a cursive script foil-blocked in gold, and bound with a thick, twisted cord which goes through the book and is tied on the front. The covers are hinged to allow the book to be easily opened.

B050:01
Also see
B074:03|04|05 →

B050:01
Design: Birgit Eggers
Title: Central St. Martins
Fashion Degree Catalogue
310 x 220 x 20mm
76 pages
1995
United Kingdom

A tricky hierarchical problem was avoided for
this end of show fashion catalogue for Central
St. Martins College in London. The problem
of who should come before whom was
resolved by making the catalogue loose-leaf,
which also allowed a variety of different
stocks and printing processes to be used.
This method helps to create a rich and varied
series of pages, each one representing a
different fashion graduate.

These loose sheets were then placed within
a plain white card box. The box has a circular
debossed impression, which is a reference to
a private view invitation which was sent out
on a CD-rom. The title of the show is stamped
at the foot of the cover.

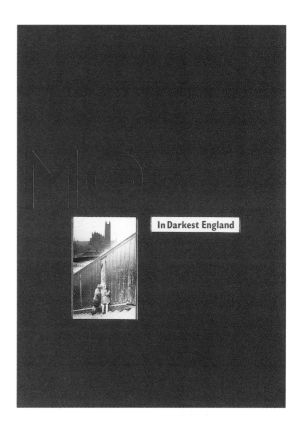

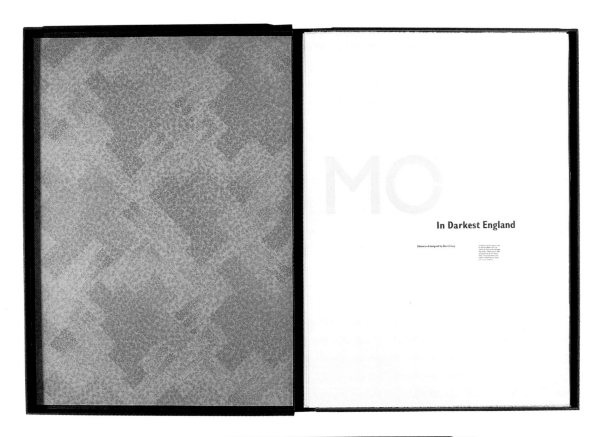

B050:02 | B051:01|02
Designer/Editor: David Jury
Title: In Darkest England
550 x 400 x 27mm
46 pages
1997
United Kingdom

This lavishly produced, limited-edition box set of loose-leaf sheets was put together by several different typographers, all working with traditional letterpress techniques. Owing to the large format of this book, the fact that it is unbound works in its favour, as it allows each page to be handled separately. The pages have been left untrimmed so the rough edges of the hand-made Italian paper add to the delicate craftmanship of the book.

The book is encased in a tailor-made dark green clam box with the letters MO embossed on the front and a frontispiece tipped on. Inside the box special decorative end paper has been added.

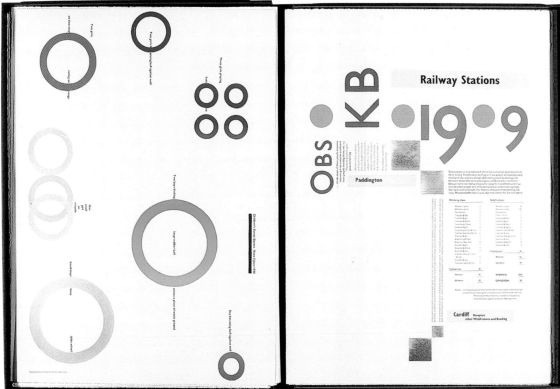

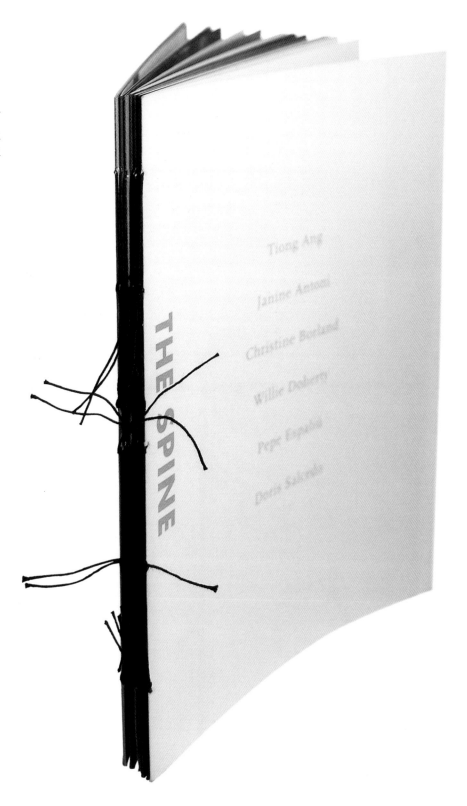

B052:01
Design: Irma Boom
Title: The Spine | Da Appel
210 x 148 x 8mm
56 pages
1994
Holland

A series of individual artists' exhibitions held under a general title of 'The Spine' needed a catalogue that could work both individually and also as a group.

This catalogue uses the title of the show as the main form of inspiration. Each eight-page booklet is bound with black thread, the loose ends of which are then bound to the loose ends of the next booklet and so on. The cover of each booklet always has the title on it, although each cover has a different colour printed full-bleed to help create contrast. This titling system allows the catalogue to be viewed with any artist at the front.

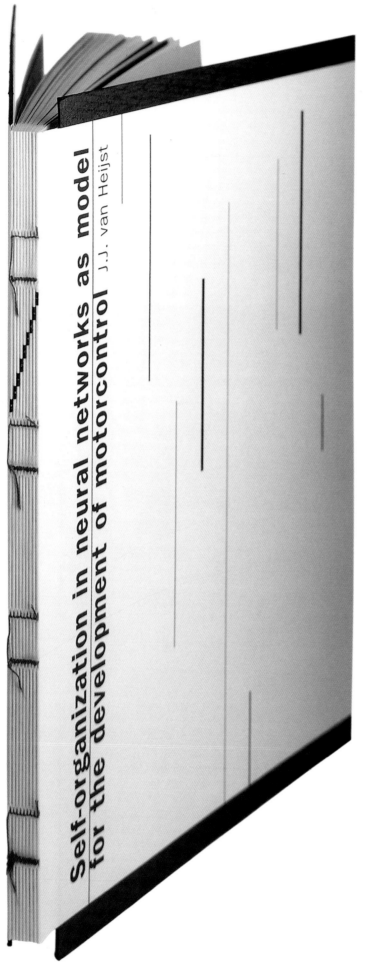

Self-organization in neural networks as model for the development of motorcontrol J.J. van Heijst

B053:01
Design: Kristel Braunius
Title: Self-organization in neural networks as model for the development of motorcontrol
260 x 170 x 11mm
140 pages
ISBN: 90-367-1001-4
1998
Holland

'Self-organization in neural networks as model for the development of motorcontrol' is a heavyweight neuro-medical book. The designer has managed to loosen the very conservative grip of this highly academic paper by creating a very original cover and spine design.

As the book's primary emphasis is on the spinal processes, the designer has turned the spine of the book into the main focal point. By exposing the sewn sections' construction and through the use of bright red thread as opposed to conventional white thread, the inner guts of the book are exposed and turned into a highlight.

The other unusual feature of the cover is the cover boards, which are cut flush to the fore-edge of the book, but extend by 10mm both top and bottom of the content. The boards are also inset by 10mm from the bound edge. Emphasis is drawn to these outsized covers by the printed paper cover sheet, which is the same format as the content of the book.

On closer inspection it is revealed that the covers are in fact the first pages of the first section of the text pages. The cover boards are simply bonded between the first and second sheets of text paper.

B054:01|02
Also see
A070:01|02|03 ←

B055:01
Also see
A046:01 ←

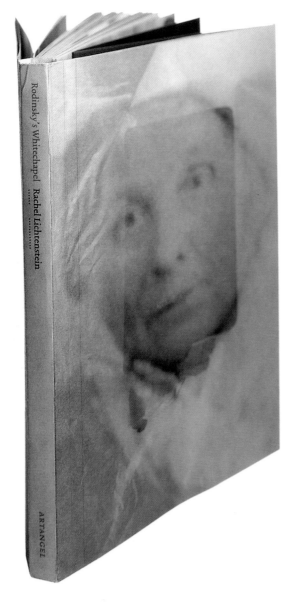

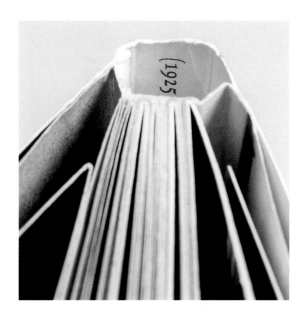

B054:01|02
Design: Mark Diaper
Artist: Rachel Lichtenstein
Title: Rodinsky's Whitechapel
165 x 110 x 10mm
88 pages
ISBN: 1-902201-06-X
1999
United Kingdom/Holland

This small pocketbook was produced as an artists' walking tour around the Whitechapel area of East London, and is based on the life and times of a Jewish immigrant who mysteriously disappeared by 1969, and whose flat was left untouched and forgotten for some 20 years.

The book itself is a sewn-section volume with a softback cover. However, the cover has an unusual folding system around the spine, so that when the book is opened the cover section comes away from the actual spine. Concealed within this hidden space are the birth and death dates of Rodinsky.

The content is printed on an off-white cotton stock, with the occasional sheet of bible paper interspersed.

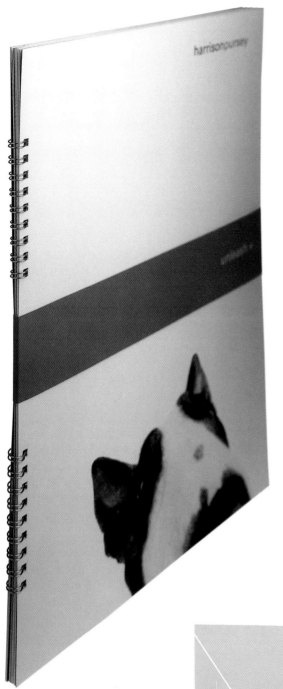

B055:01
Design: Blast
Title: HarrisonPursey – Unleash
330 x 250 x 4mm
20 pages
1999
United Kingdom

Although on the whole a conventional brochure for a London-based recruitment agency, this booklet is wire-bound by two short strips which makes a pleasant break from regular wire-bound documents.

The brochure is also sealed with a paper belly band with the word 'unleash' printed on the right, a reference to the dog theme that runs throughout the whole brochure.

B055:02
Design: Graphic Thought Facility
Title: Stealing Beauty –
British Design Now
252 x 150 x 9mm
106 pages
1999
United Kingdom

Designed as an accompaniment for an art exhibition at the ICA in London, which had a general theme of street art and contemporary ready-mades, the cover of the brochure features an image of the punched hole 'confetti' that would result from the waste after the binding process. The binding is of the cheap plastic-comb variety; however, the plastic is clear, which is rarely seen.

Inside the catalogue various stocks and different sizes are used, some printed full-colour and others in mono. An interesting feature at the front of the catalogue is the sponsor's credit, that of the champagne producers Perrier-Jouet; an actual champagne label has been bound into the contents page.

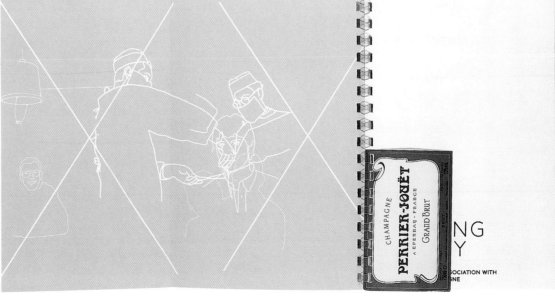

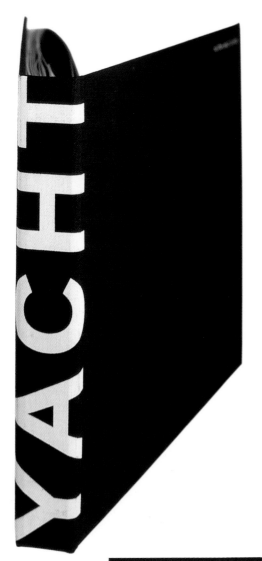

B056:01|02
Design: Wolff Olins
Title: Yacht – to the next curve
150 x 150 x 20mm
58 pages
1999
United Kingdom

A special launch brochure for this re-branded company comes in the shape of a black cloth-covered, case-bound book with the new company name printed in white down the spine, at a size that enables the typography to bleed around onto both front and back covers.

As the book is opened there are three sections, the first a singer-sewn-bound introductory brochure which is bound into the cover of the book. This is followed by two pockets, the first of which contains another booklet setting out the key missions of the company, and the second containing a fold-out visual leaflet.

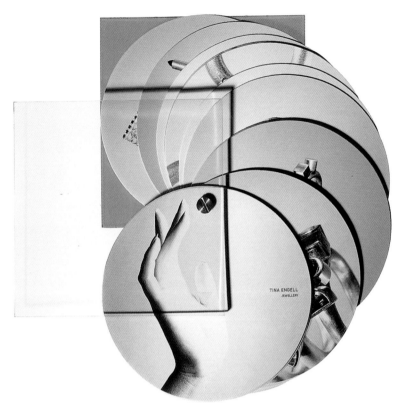

B057:01
Design: Area
Photography: Toby McFarlan Pond
Title: Tina Engell Jewellery
132 x 132 x 20mm
40 pages
1996
United Kingdom

An original format and binding system is used for this jewellery designer's promotional brochure. Relating to the fact that most rings and bracelets are circular in form, the pages of the brochure continue this idea. However, the outer covers are made of two different-coloured sheets of Perspex, cut to a square format.

The binding is one brass binding screw, which allows the brochure to be fanned out to show various pages at the same time. The result is a brochure that while being experimental is also very practical to use.

B057:02
Design: KesselsKrammer
Title: Thuis in Amsterdam
210 x 210 x 8mm
40 pages
1999
Holland

Produced for the Dutch newspaper 'Het Parool', this book is very understated from the outside. The pale turquoise cover boards have the title of the book embossed and foil-blocked with a clear varnish. The book is produced as sewn sections, with an olive-green binding cloth visible on the spine. This colour is also used on the end pages.

B058:01|02
Design: John Cole
Artist: Verdi Yahooda
Guidelines to the System
234 x 180 x 11mm
48 pages
ISBN: 1 870699 04 1
1990
United Kingdom

This artist's book has a cover made from manilla-coloured pattern-cutters board which has been doubled back on itself for added stability, and stitched together with white thread. The title and artists' names are only revealed on the inside back cover. The front cover shows a detail from a pattern for a lady's bodice, which is foil-blocked in white.

Inside, the binding system is revealed; a nickel-plated metal pillar with a swing-clasp fastening on the front. The content is made up of a collection of loose sheets, all black and white, with one section containing a series of photographs illustrating the correct fitting of a bra; another section containing a series of x-ray-quality photographs of dressmakers' pins and antiquated tailoring tools.

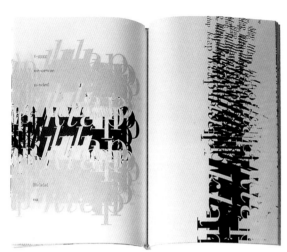

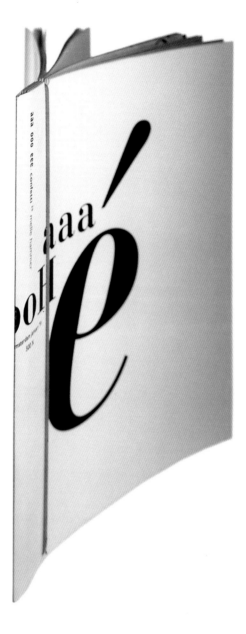

B059:01|02|03
Design: Melle Hammer
Title: AAA OOO EEE – Confetti 25
200 x 160 x 5mm
54 pages
1991
Holland

This experimental book plays with phonetics and visual sounds associated with the word 'klap' using expressive typographic design. The cover is printed on a cast-coated stock in black and white, and is bound with an elastic band (originally red).

The whole book is French-folded which adds a great deal of depth and colour to the predominantly mono pages. The majority of the content is printed on bible paper interspersed with glass tissue paper and a manilla-coloured sheet to add a little extra colour and variety.

The design of the French-folded pages has been highly considered, building densely overlaid typography to create a richness and delicacy otherwise not possible.

The book is bound using an elastic band looped around the book from top to bottom. The elastic is held in position by a half-circle hole punched through the extent on both top and bottom edges. This binding method, although very simple in construction, works remarkably well, as the elastic allows for a certain degree of flexibility and movement when looking at the spreads.

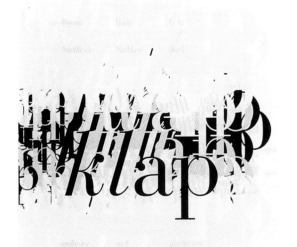

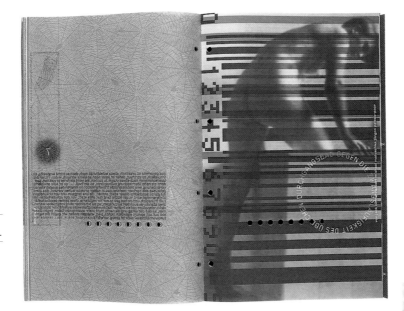

B060:01|02|03|04
Also see
B006:01|02 ←

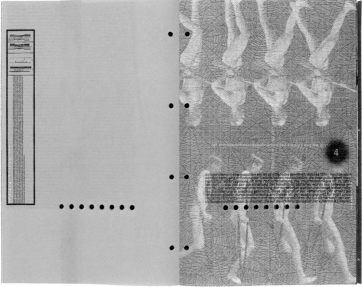

B060:01|02|03|04
Design: cyan
Title: Form+Zweck 11/12
324 x 211 x 13mm
152 pages
1994
Germany

'Form + Zweck' is a design journal published in Germany. The format of the publication varies from issue to issue. Issue 11/12 shown here comes as a sealed block with initially no obvious means of entry. On the back of the book is a set of basic instructions in both German and English, which read as follows:

"Attention:
(1) remove this carefully. (2) please remove two of the three rear cardboard sheets. (3) turn up with the cover closed. (4) open it. (5) remove the flap at the perforation. (6) take out the rivets. (7) rivet it at the spine."

On closer investigation, along one edge is a discreet perforated crease fold. With a certain degree of care one can peel open the book to reveal the content. However, once inside the reader is requested to complete the binding process, as described above. The book has a series of four holes running down the left edge in readiness for the final stages of binding. There is another series of eight closely set holes running horizontally across the lower quarter of the book. These holes are used for the storage of the binding rivets, which can be accessed from the inside back cover. It is then a case of simply following the instructions to complete the binding process.

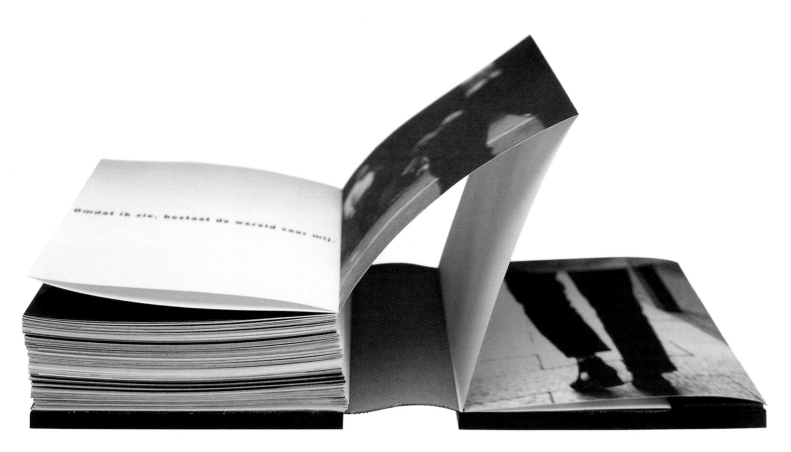

B061:01|02
Design: Britta Möller
Title: Kijken & Denken
120 x 100 x 40mm
152 pages
60 x 50 x 10mm
18 pages
60 x 50 x 10mm
18 pages
1998
Holland

Working as one main book and two small text translation books, this artist's book comes inside a numbered plastic bag. The larger book is a 152-page concertina-folded volume, which can be released at the back and unfold to a total length of 15m if so wished. The covers are made of thick, black Perspex, with the title silkscreened in black. The book is bound with a bookbinding cloth.

The two small books, one in English and the other in Dutch, are again concertina-folded and bound with a cloth spine and grey bookbinding board covers.

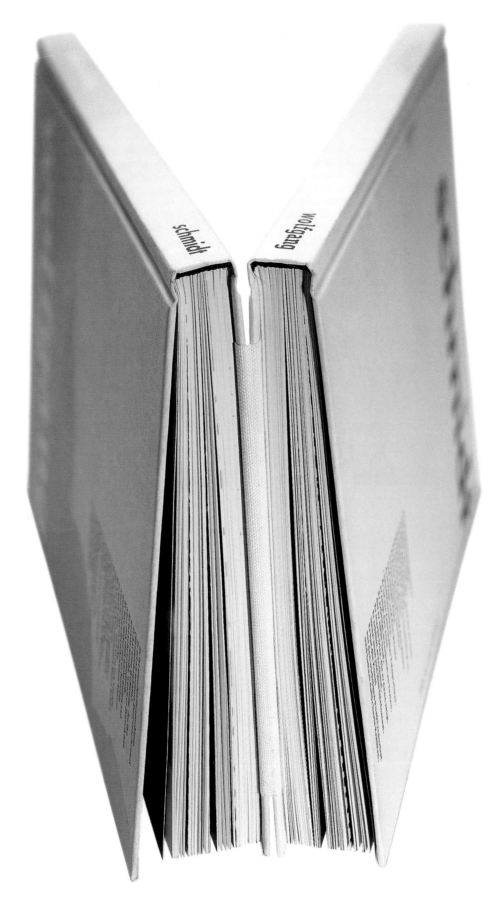

B062:01 | B063:01|02|03
Design: Anke Jaaks
Title: Wolfgang Schmidt –
Worte und Bilder
241 x 151 x 28mm
2 x 128 pages
1992
Germany

Produced as a thesis on the work of the German graphic designer Wolfgang Schmidt, this unusually formatted book works across two separate case-bound volumes, which are themselves bound together.

The two volumes work perfectly well as single volumes, but certain images and text work across both halves, making the design very interactive. The two volumes are bound together with a strip of grey bookbinding cloth, which acts as a hinge.

Inside, although mostly conventional, one section (which appears at the same position in both volumes) is printed on tracing paper, while at another point a sheet of coarse brown packing paper is bound in.

Another interesting feature of the book is the subtle change in typography from one book to the other. The 'Wolfgang' book is printed in Officina Serif, while the 'Schmidt' book uses Futura, the preferred font of Schmidt himself.

Once folded in half, the book is housed in a matt-black slip case, with 'Wolfgang' silkscreen-printed in white on the front and 'Schmidt' printed on the spine.

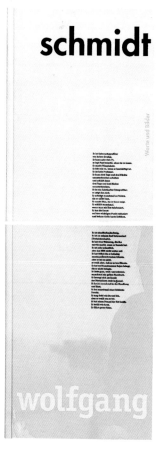

08_Interaction

**Introduction
by John O'Reilly**

B066:01
Also see
B070:01|02|03 →

B066:02
Also see
B076:01|02 →
B077:01|02|03 →

B067:01
Also see
B072:01|02 →
B073:01 →

"Postwar Europe, sceptical and bewildered, is cultivating a shrieking, bellowing language; one must hold one's own and keep up with everything. Words like 'attraction' and 'trick' are becoming catchwords of the time. The appearance of the book is characterised by: (1) fragmented type panel, (2) photomontage and typomontage.

"All these facts are like an aeroplane. Before the war and our revolution it was carrying us along the runway to the take-off point. We are now becoming airborne and our faith in the future is in the airplane – that is to say in these facts." El Lissitzky 'Our Book'.

Each new technological invention brings its own catchword or buzzword. The buzzword makes the technology happen and shifts our behaviour. New technology creates new possibilities for communication and creates new concepts. Though the slogan among revolutionary Russia was 'materialism', El Lissitzky argued that the phenomenon that characterised the age was dematerialisation. "An example: correspondence grows, the number of letters increases, the amount of paper written on and material used up swells, then the telephone relieves the strain." Likewise, as the weight of telephone communication increased, the radio emerged as a disseminator of information.

The web and the internet brought their own vocabulary of logging on. And as the media developed new concepts, buzzwords were required. If the word 'interactive' died, it would come back as a bee. 'Interactive' is the buzzword of the new millennium. It's buzzier than a whole hive of bees. It's even brashly inserted its initial before the medium of the late 20th century, iTV. But what does 'interaction' mean?

To television executives having to cope with the dynamic of interactivity that has travelled over from the internet, interaction means 'betting'. In the near future interactive television will mean gambling on two snails racing up a wall, or betting on which drunken student throws up his Indian takeaway first. In the language of El Lissitzky, books are increasingly competing with dematerialised, or virtual content. When teledildonics is finally available over the internet, and with pizza on tap at the end of a phone, will books have to 'put out', show some skirt, ripple a well-toned six-pack like an all-singing, all-dancing Robbie Williams?

The examples of books in this section are all in some sense 'interactive'. When the interactive element doesn't work it is merely a kind of lo-tech special effect. But all of them at least raise the question of 'interactivity'. If this book had been produced ten years ago, or even five years ago, would there have been a chapter entitled 'interaction'? Unlike conventional books who have readers, these books all have a different relationship with their owner. They are 'users' rather than readers. Built into these books is a kind of mechanics. The books are machines.

In an interview with Steven Heller, designer Edwin Schlossberg, who creates interactive environments for museums, shops and public attractions, defines some basic criteria that successful interactivity should produce. "Interaction must enable its participants to learn more about the subject, themselves and others within the experience." But while that is really an aspiration rather than a defining feature of the interactive, he identifies one important feature of interaction: "Interaction must develop from the use by its participants – it must learn and change according to its users' action."

A famous example of this type of interaction in the book form was created by novelist B.S. Johnson with his novel 'The Unfortunates'. Its binding was the box it came in. In the graphic design review Eye magazine, artist Robin Rimbaud described Johnson's book as "a unique object – 27 loose-leaf sections, temporarily held together with a removable wrapper with only the first and last sections specified. The remaining 25 passages could be shuffled into any order one wished, a 'physical tangible metaphor' for the workings of the mind."

Bruno Munari's children's book 'La Favola delle Favole' reworks Johnson's design template. The pages are loose so they can be arranged in any order and held together by two bulldog clips. It also provides textured materials such as gauze and tracing paper which add a dimension in creating an environment.

And it was an artist who produced one of the most commercially successful children's picture books of recent times. 'I Want To Spend The Rest Of My Life Everywhere, With Everyone, One To One, Always, Forever, Now' is a children's book masquerading as an artist's monograph.

It was a collaboration between designer Jonathan Barnbrook and artist Damien Hirst. Even the title itself has the air of childhood fantasy. The title page on the inside has the artist's name marked out in a stencil. As you go through the book you are presented with a series of pull tags, pop-ups and stickers. The book's interactive component is as much an interaction with Hirst's oeuvre itself as it is with the reader.

On one page there's a spot painting where you can change the spots by pulling a tab. The popularity for young children of interactive 'pull-tab books' rests in being able to make images appear and reappear, in being able to control an environment. And the child's pleasure, as every parent knows, is partly derived from the endless repetition of the game. In his notorious essay 'Beyond The Pleasure Principle', Sigmund Freud observed the habits of his grandson at play. The little

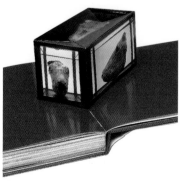

boy was about 18 months old and would play a game of 'disappear and return' with a cotton-reel toy. Every time the boy threw the reel away and reeled it back it was accompanied by the sounds of 'ooo' which sounded like the German word 'fort' (gone), and 'a' which sounded like 'da' (there). Freud initially believed that the little boy was trying to master feelings aroused by the mother's occasional absences. He gained a measure of control by playing out her absence and return. In his comments on his art Hirst plays hide and seek with the general public. He throws out an idea of what his work is about, and then takes it back, partially.

According to designer Jonathan Barnbrook, "The pop-ups were about playfulness. Art should be a fun thing, it shouldn't be an academic subject. It was Damien's idea. I didn't like the idea at the beginning. But it was that playfulness that was important." You can imagine Barnbrook's initial reservations. Is this a gimmick? But its resonances with children's books do inflect your perception of Hirst's art. On one page opposite an image of Hirst's famous pickled shark 'The Physical Impossibility Of Death In The Mind Of The Living', there is a quote from the artist: "The huge volume of liquid is enough. You don't really need the shark at all." When you pull the tab beside the image the shark disappears, revealing an empty tank. In a way the mechanics borrowed from children's books do really underline the theatricality of Hirst's work. It's a laboratory of the Grand Guignol.

A very different kind of interaction is created by <u>Union Design's The Tangerine Book</u>. It is a booklet for Tangerine product design consultancy, and its purpose was to showcase some of its products as well as communicating the design philosophy behind the company. The solution was to divide up the theoretical from the practical. It has a plain tangerine cover without a title. You flick through the book, and you are presented with an alphabetical series of branding concepts from 'Character' to 'Spirit'.

These ideas are in effect a contemporary philosophy of the commodity object. Tangerine explain the relationship between the consumer and new technology by the idea of interplay. "In products that do not derive from traditional precedents and where the workings occupy ever less space, almost all that is left is the interface between the user and the product and the often complex interaction of the user with the product across that interface. As everywhere, design here should be logical and straightforward, but also enjoyable. Interaction should lead to interplay." The prose isn't straightforward, but you get the idea.

The casual reader will put the book down having read a book of commercial design philosophy. But pick it up again and flick from back to front and you have a different book showcasing products with brief captions on their design principles. The effect was achieved by the simple procedure of making each alternate page 3mm shorter at the side. It's this virtual 3mm that creates two simultaneous parallel books.

The Tangerine Book is truly interactive in that it makes you rethink completely the nature of the object. What you thought was simply a manifesto materialises the idea of 'interplay'. And looking at the inventive interaction of The Tangerine Book merely highlights the confusion around the new media notion of interactivity. Filling out a form on the internet or on digital TV is the same as filling out a form on paper. The worldwide phenomenon of the 'Big Brother' TV series was presented as interactive, as if having a vote on the individual you wanted to eject from the house was any more interactive than filling in a questionnaire.

There is one simple technique of introducing interactivity which is used in The Tangerine Book – through a 'delay effect'. You think the book is one thing, but your whole perception is changed by discovering the other book inside. Your single point of view is multiplied. This delay effect has been used by writers such as Flann O'Brien in his novel 'The Third Policeman', which reveals to the reader at the end that the narrator is in fact dead. Or in the cinema, 'The Fight Club' uses the same technique when you finally discover that Brad Pitt's character, who you've identified with, loathed, admired, is merely an externalisation, a projection of the personality of Edward Norton.

There is no point in being sentimental about books. In our Darwinian media-ecology, books will survive as long as we want them. As the examples in this section show, perhaps they could be reinvented. We mightn't even recognise the book of the future. El Lissitzky pointed out that during the revolution the book took a completely different form. It was fragmented, ripped apart and became a poster. In our own time books are becoming more like magazines and magazines like books. As books respond to a media environment characterised by 'interactivity', the book may take on a different form again. El Lissitzky recognised the fact that the inundation of children's picture books would change their perception. "By reading, our children are already acquiring a new plastic language: they are growing up with a different relationship to the world and to space, to shape and to colour; they will surely create another book." Substitute 'logging on' for 'reading', and perhaps we will also see an evolution of the book.

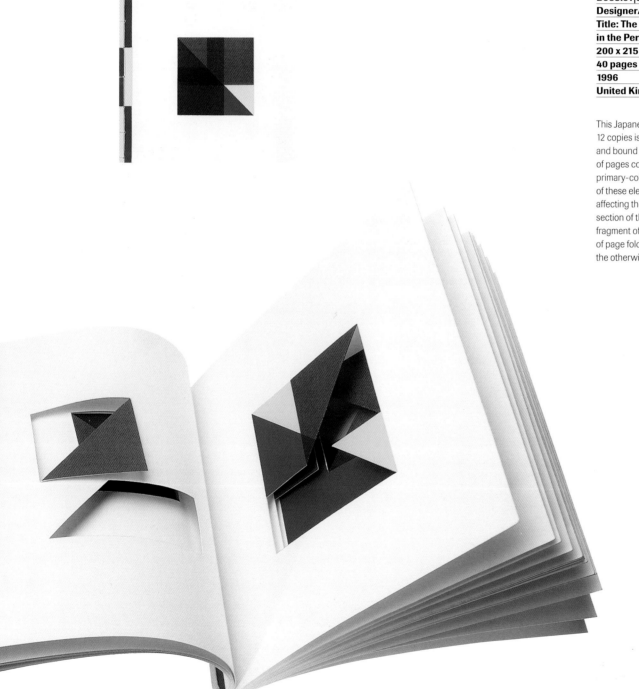

B068:01|02 | B069:02
Designer/Artist: Paolo Carraro
Title: The Impermanent
in the Permanent
200 x 215 x 8mm
40 pages
1996
United Kingdom

This Japanese limited-edition artist's book of
12 copies is silkscreen-printed, cut, folded
and bound by hand. It contains a sequence
of pages comprising a square block of
primary-coloured units. On each page one
of these elements is moved or changed,
affecting the whole. Further to this a triangular
section of the page is folded back to reveal a
fragment of the following page. This system
of page folding allows colour to appear on
the otherwise blank verso side of the page.

B069:01
Designer/Artist: Paolo Carraro
Title: The Impermanent
in the Permanent (mono version)
216 x 216 x 23mm
40 pages
1996
United Kingdom

Produced by the same artist as the other example on this spread, this book is produced as a series of loose sheets contained inside a clam shell cloth-covered box. The same principles and systems are used on this book, with the exception that the entire book is produced in just black and white.

The advantage of this book being loose-leaf is that the reader can interact further with the pages. By simply turning the pages through 90 degrees one can alter the compositions; the possibilities for alternative compositions seem almost limitless.

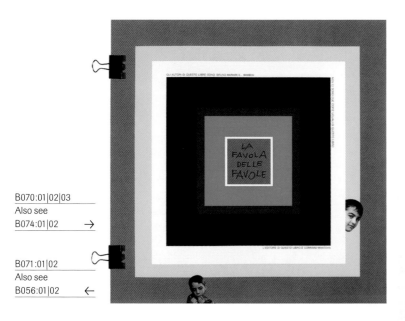

B070:01|02|03
Also see
B074:01|02 →

B071:01|02
Also see
B056:01|02 ←

B070:01|02|03
Design: Bruno Munari
Title: La Favola delle Favole
300 x 300 x 9mm
126 pages
ISBN: 88-86250-60-6
1994
Italy

Produced as a children's book, this large-format loose-sheet book is simply bound with two bulldog clips, allowing the pages to be removed and reshuffled.

The idea behind the book is to let the child's imagination run free and create their own stories and drawings. The introduction begins by saying: "Every book of stories, tales or fables is made by putting together people that do as they wish, in certain places, while the weather behaves in its usual capricious way. Four elements go into the making of a story: the people, the places, the events, the weather."

The rest of the book is made up of half-finished drawings, coloured sheets of paper – some blank, others with shapes cut into them, sheets of tracing paper, and other textured materials such as gauze: effectively all the necessary ingredients to create the story.

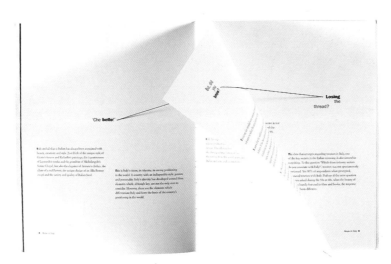

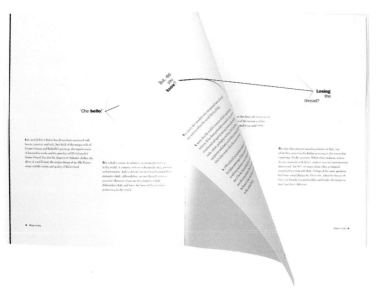

B071:01|02
Design: Wolff Olins
Title: Made in Italy
280 x 228 x 4mm
24 pages
1996
United Kingdom

Produced as a report on "the perception of national images in the context of today's global markets", this simple brochure printed in red and black outlining key areas of development is enlivened by the use of a piece of thin red string which is threaded through three spreads. As the pages are turned the thread is pulled taught as the pages pass across it.

In the introduction the relevance of the thread is revealed as a reference to Greek mythology when Ariadne, daughter of Minos, gave a ball of red thread to Theseus to unwind as he went into the Labyrinth where the Minotaur lived. And so, by following 'Ariadne's thread', Theseus found the route out (and the road to success).

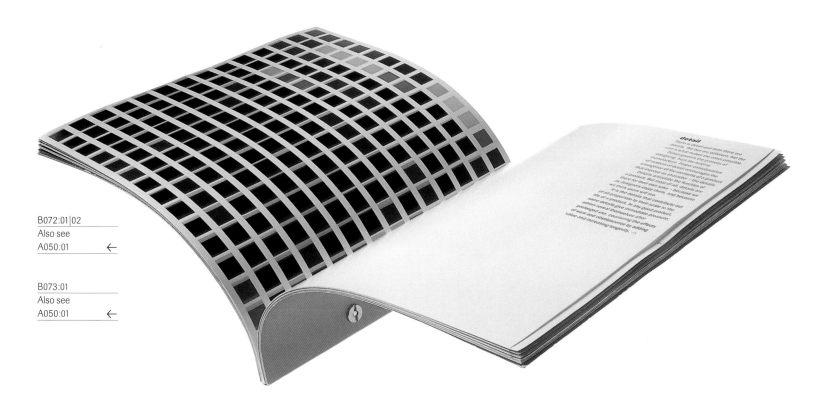

B072:01|02
Also see
A050:01 ←

B073:01
Also see
A050:01 ←

detail

B072:01|02 | B073:01
Design: Union Design
Title: The Tangerine Book
205 x 235 x 17mm
64 pages
1995
United Kingdom

For this brochure for a London-based product design consultancy, the designers responded to the combined brief of showcasing the company's work while also conveying their philosophy by producing two books within one. Each book would work in parallel with the other.

These two separate halves are intermeshed through a clever process of cutting each alternate page 3mm shorter. This simple process results in a brochure that when flicked in one direction reveals just the design philosophy and when flicked in the opposite direction shows only the product section.

This effect is heightened by the contrast of very colourful pages used on the design philosophy section against the monochromatic product pages. The cover has no title or text on, which adds to the brochure having two fronts.

Flatliner
Stare Pheos

Bathroom Furniture

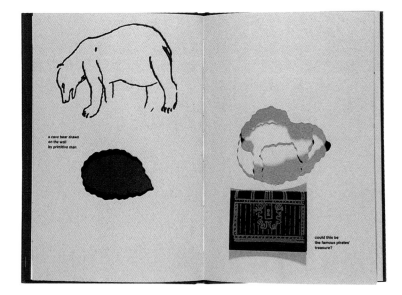

B074:01|02
Design: Bruno Munari
Title: Nella Notte Buia –
In the Darkness of the Night
235 x 165 x 10mm
60 pages
ISBN: 88-86250-38-X
1996
Italy

A simple children's book which utilises a variety of different stocks as well as sections printed on tracing paper with illustrations that form three-dimensional spaces.

After the first section of black stock with a small die-cut hole lit by a firefly, the reader journeys on to the next section of tracing paper printed with long grasses, which leads the reader through the grass and its various insect inhabitants. The reader then comes out of the grasses and enters a big cave made of irregular-shaped holes cut through the whole of this section. The cave is covered with prehistoric paintings and a treasure chest.

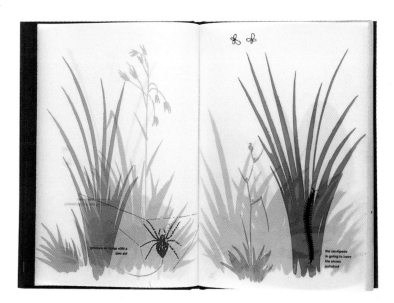

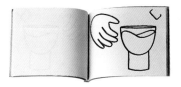
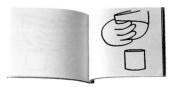

B074:03|04|05
Design: Birgit Eggers
Title: Radar Glass
38 x 54 x 2mm
38 pages
1998
United Kingdom

An animated instruction manual with no words; instead, simple line drawings are used to illustrate how to use a two-sectioned vase/bowl. The leaflet is intended to be used as a flick book.

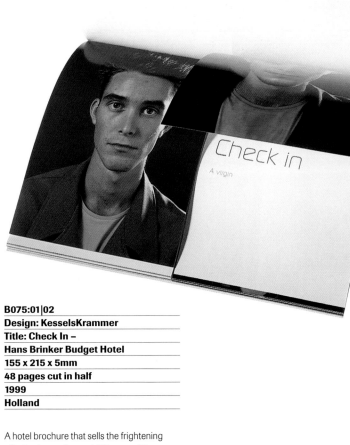

B075:01|02
Design: KesselsKrammer
Title: Check In –
Hans Brinker Budget Hotel
155 x 215 x 5mm
48 pages cut in half
1999
Holland

A hotel brochure that sells the frightening effects of spending a night in one of its rooms. The content of the book is cut down the middle, allowing a 'before and after' (check in/check out) case study of various patrons of the hotel.

On the left are portraits of various visitors at the time of 'check in'. Then as the split pages are turned the same visitor is shown at the time of 'check out', usually bruised, battered and looking less than refreshed! Witty examples are used such as "Check in with girlfriend, check out with boyfriend", "Check in a virgin, check out a pro", "Check in full of dreams, check out full of cheap beer".

The cover of the book is made from a grey flocked material with the title foil-blocked in white, with the 'check in' on the front and 'check out' on the back.

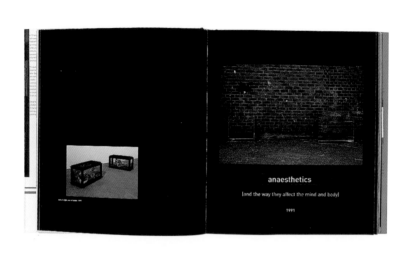

anaesthetics

[and the way they affect the mind and body]

1991

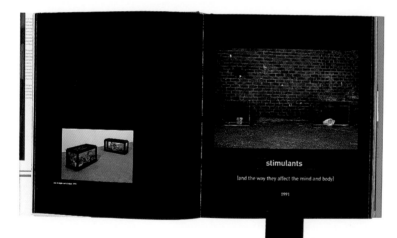

stimulants

[and the way they affect the mind and body]

1991

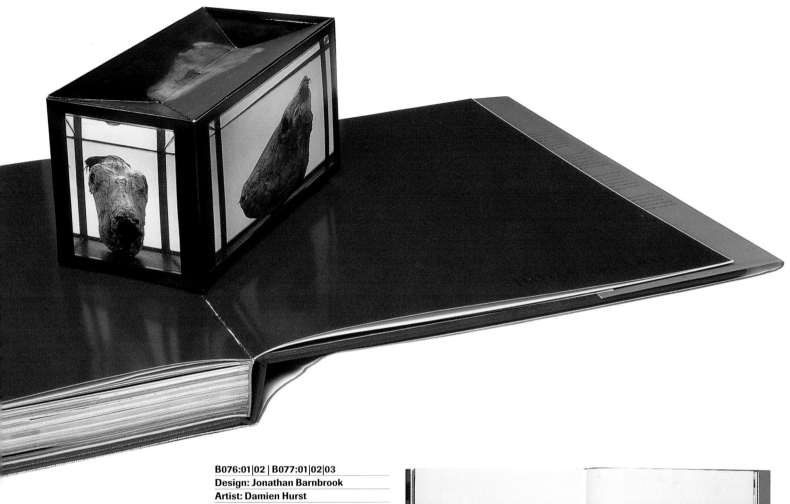

B076:01|02 | B077:01|02|03
Design: Jonathan Barnbrook
Artist: Damien Hurst
Title: I Want to Spend the Rest of
My Life Everywhere, with Everyone,
One to One, Always, Forever, Now
338 x 300 x 38mm
366 pages
ISBN: 1-873968-44-2
1997
United Kingdom

An example where a fine artist and a graphic designer work closely together to generate a truly interactive book. The book is somewhere between a artist's monograph and a children's play book. It employs a wide diversity of print techniques such as pop-ups and pulling tabs to show before and after scenes, tipped-in pages, die-cut holes, fold-out sections, acetate overlays and sticker sheets.

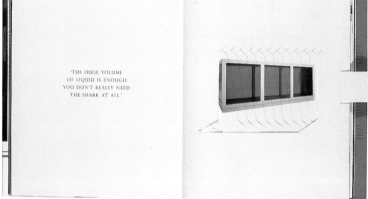

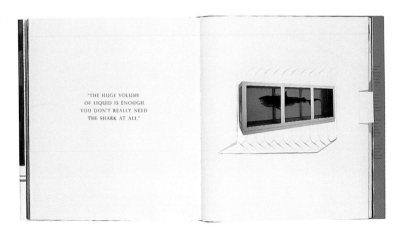

09_ Reading list | Glossary

Design Dialogues
by Steven Heller and Elinor Petit,
Allworth Press, New York, 1998

Looking Closer 3:
Classic Writings on Graphic Design,
Allworth Press, New York, 1999

Empire of Signs
by Roland Barthes
Hill and Wang, 1982

Understanding Media
by Marshall McLuhan
Ark Paperbacks, 1987

Essential McLuhan
edited by Eric McLuhan and
Frank Zingrone
Routledge, 1997

Michel Foucault Philosopher
by Gilles Deleuze
translated by Timothy J. Armstrong
Routledge, 1992

The Fold: Leibniz and the Baroque
by Gilles Deleuze,
translation by Tom Conley
University of Minnesota Press, 1993

Species of Spaces and Other Pieces
by Georges Perec
translated by John Sturrock
Penguin, 1997

Postmodernism, or, the cultural
logic of late capitalism,
by Frederic Jameson
Verso, 1996

Hand-Made Books
by Rob Shepherd
Search Press, 1994

The Thames and Hudson Manual
of Book Binding
by Arthur W. Johnson
Thames and Hudson, 1978

Paperwork
by Nancy Williams
Phaidon Press, 1993

Basic Typography
by John R. Biggs
Faber and Faber, 1968

Artist/Author
Contemporary Artists' Books
by Cornelia Lauf and Clive Phillpot
Distributed Art Publishers Inc., 1998

Designing Books
Practice and Theory
by Jost Hochuli and Robin Kinross
Hyphen Press, 1996

Unica T
Ten Years of Artists' Books
by Anja Harms, Ines V. Ketelhodt, Doris
Preussner, Uta Schneider, Ulrike Stoltz
Unica T, 1996

I would like to extend my deep thanks to all those who have helped in creating this book, whether by kindly submitting work or for help and advice.

A special thank you should be extended to both Chris Foges and John O'Reilly for their enthusiasm; Sanne, Tristan and Minnie for their constant support and understanding; Zara, Brian and all at RotoVision for their faith and patience; and the boys and girls at Struktur for all the effort. Finally a big thank you to Xavier for visually explaining complex book designs through the lens.

rf-t

Roger Fawcett-Tang is a founding partner of Struktur Design, which works predominantly in the print-based medium across a diverse range of sectors. Struktur's work has been reproduced in several international design annuals and has won awards for its music packaging and editorial design work.

Chris Foges is a journalist specialising in design. He has previously been the editor of Graphics International magazine, and has written for various other titles including Print. He has written two other titles for RotoVision: Letterheads and Business Cards, and Magazine Design.

John O'Reilly writes for Eye magazine and produces material for online magazines and design agencies on technology, culture and business. He has been an editor at The Modern Review, Colors magazine, a regular contributor for The Guardian and Independent newspapers, and a lecturer at Central St Martin's School of Art and Design.

Bellyband
A strip of paper or other material that wraps around the centre of the book to prevent the pages from opening.

Bible paper
A very thin paper usually between 40–60gsm in weight, used for amongst other things, bibles, directories and dictionaries.

Binding screws
Small brass thumb screws consisting of a male and female part, used to bind loose sheets together. Usually available in brass or nickel plated (silver).

Book-binding board
A dense fibre-board used for the covers of case-bound books.

Case-bound
The term used for a hardbacked book.

Cast-coated
Paper which has a very high quality, high-gloss surface on one side while the reverse remains matt and uncoated.

Clam-shell box
A box made from two hinged halves which sit inside each other. Often used for holding loose-leaf documents.

Coated stock
A smooth hard-surfaced paper ideal for reproducing half-tone images, created by coating the surface with china clay.

Concertina-folded
Pages folded in a zigzag manner like the bellows of a concertina.

Debossed
A surface pattern pressed into the page, also known as blind embossing.

Die cut
The method by which intricate shapes can be cut from the page. The process requires a custom-made die which has a sharp steel edge constructed to cut the required shape.

Embossed
A raised surface pattern created by using a male and female form.

Endpapers
The first and last pages of a book, bonded to the inside of the hardback covers.

Foil blocking
Printing method using a metallic foil applied to the page by a metal block and heat.

Fore-edge
The front or open edge of a book.

French-fold
The method of folding a page in half and binding along the open edges.

High-density foam
A special type of foam which has a higher density than normal, and which can be cut with great accuracy to form precision recesses.

Imposition
The order in which pages are arranged so that after printing and folding the pages read in the correct sequence.

Japanese binding
A method of binding where the thread is bound from the back to front of the book and around the outside edge of the spine. Ideal for binding loose sheets.

Lenticular
Normally constructed from two interlaced images filtered through a special sheet of plastic which has lens-shaped ridges on the surface. This allows one or other of the images to be viewed depending on the angle at which the surface is held.

Live-edge Perspex
Fluorescent-coloured translucent Perspex which refracts light through its mass, giving an almost electric vibrancy along all the edges.

Loose-leaf
A collection of unbound pages.

Perfect-bound
A method of binding single leaves together using only glue.

Polypropylene
A flexible plastic sheet available in many different colours including clear and frosted.

Recto|Verso
Terms to describe the open pages of a book; recto being the right-hand page and verso the left-hand page.

Saddle-stitched
The standard method for binding brochures and magazines. The process involves gathering the pages to be bound and stapling them through the folded edges.

Sewn section
The method of binding whereby a group of eight or sixteen folded pages are gathered together and sewn through the folded edges. These sections can then be bound together to form a complete book.

Simulator paper
A thin, translucent paper, more commonly known as tracing paper.

Singer sewn
An industrial version of the household sewing machine, used to stitch a book by sewing through the front to the back. Used mainly on loose-leaf and French-folded documents.

Slipcase
A protective box with one edge open into which a book can be stored.

Tipped-in
A term describing the action of gluing supplementary paper into a book.

Uncoated stock
A rougher surfaced paper than coated paper, but more opaque and bulkier.

UV varnish
A plastic-based varnish applied by silkscreen printing, available in matt, satin or gloss. Can be applied over the entire surface or treated as a 'spot varnish' allowing the designer to print type or images in a subtle varnish.

Experimental Formats
—Books
—Brochures
—Catalogues